IMAGES
of America

THE LOST VILLAGE
OF DELTA

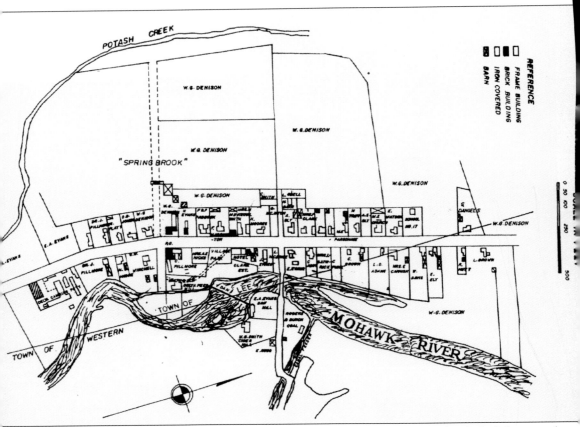

The following text labels appear on the map:

POTASH CREEK

W. G. DENISON

W. G. DENISON

"SPRING BROOK"

W. G. DENISON

W. G. DENISON

W. G. DENISON

W. G. DENISON

DANIELS

W. G. DENISON

TOWN OF WESTERN

TOWN OF LEE

MOHAWK RIVER

W. G. DENISON

REFERENCE
FRAME BUILDING
BRICK BUILDING
IRON COVERED
BARN

SCALE IN FEET
0 50 100 250 500

This 1907 map shows Delta. Note that the village is laid out in a neat and orderly fashion, with village lots approximately the same size and the mills nestled on the bend of the river. An early settler, Israel Stark, had the area surveyed and laid out the basic plan for the village. (Courtesy of *Oneida County Atlas*.)

On the cover: The Henry Beach real-photo postcard shows a load of peas going down Short Hill Road to be processed at the Olney and Floyd canning factory. The wagon is crossing Potash Creek, which was reported to be a great trout steam. Short Hill Road became Main Street in Delta. (Courtesy of Jack Olney.)

IMAGES
of America

THE LOST VILLAGE
OF DELTA

Mary J. Centro

ARCADIA
PUBLISHING

Published by Arcadia Publishing
Charleston, South Carolina

Printed in the United States of America

Library of Congress Catalog Card Number: 2007934929

For all general information contact Arcadia Publishing at:
Telephone 843-853-2070
Fax 843-853-0044
E-mail sales@arcadiapublishing.com
For customer service and orders:
Toll-Free 1-888-313-2665

Visit us on the Internet at www.arcadiapublishing.com

*To my son Jason and Shenna, his gold dog, who spent
many hours listening to my stories of Delta*

CONTENTS

ACKNOWLEDGMENTS

A very special thank-you is extended to Andrew Smith of Rome, who generously shared copies of the rare New York State Canal Contract 55 photographs that belonged to his grandfather Earl Scothon. We would not know what the many buildings looked like without these photographs. Mary June Pillmore wrote many articles for the *Rome Sentinel* that told of village life. If it had not been for her efforts, we would not know about the village or its people. My great friend June McLaughlin, granddaughter of Mary June and Johnson Pillmore, told me many delightful stories about her grandparents; what a good time we had. Craig Williams of the New York State Archives helped me navigate the many files in his care. Tom Gates was always on the lookout for Delta photographs and generously shared his many finds. Freida Royal Smith invited me into her home and shared her family photographs. My grandson Jacob Reed helped to build the miniature Delta village that was used at many of my slide shows. Thanks to Virginia Ackerman, Town of Lee historian, who answered many questions. Thank you to the many people who have allowed me to use their photographs in this book. Without the many articles printed in the *Rome Sentinel*, *Utica Globe*, *Boonville Herald*, and others, the village would be lost to us. Thank you Darkrooms Unlimited. This is a sincere thank-you to all my friends and family who encouraged me to write about the people and places of Delta. Locally there are many relatives of the people who lived in Delta. If you are one of these individuals and are willing to share any information, it would be greatly appreciated.

Please note that unless otherwise noted, all images are from the author's collection.

INTRODUCTION

Delta was a country village that had the same postmaster for over 30 years and where families farmed the land for generations. The valley was a secure place where people were born, lived, and died. The Delta river valley was a prosperous thriving area with its center being the village and its life lines being the Mohawk River and the Black River Canal. The village was a beautiful place where the residents enjoyed their country life, friendly neighbors, and peaceful atmosphere.

The village of Delta was originally situated in the town of Western, which consisted of 40,000 acres and sets in the center of Oneida County. Many of the early shops and businesses were established in the village, which was in the western portion of the town. As early as 1788, settlers were soon coming to the area. Rozel Fellows, who was the first white man to settle north of Fort Stanwix, settled on the hills close to the future site of the village. Soon after, the Sheldon brothers came to the area and took up acreage on the Mohawk River flats, in the area of present-day Kettle Hill. Soon more and more settlers were coming to the area. Israel Stark came in the early 1800s and planned the village, a place he called Union Valley. Prosper E. Rudd came from Connecticut and established the early gristmill and other mills. David Smith Sr. built the first sawmill, an important enterprise, for the building of the new homes and stores. As the small settlement grew, friends and relatives of the early settlers came to settle on the fertile farmlands of the Mohawk and surrounding hills. When the town of Lee was formed in 1811, the village then straddled the two town lines, with more than 80 percent of the village in Lee township. The feeder for the Black River Canal was finished in 1855 and brought new life and prosperity to the village. A canning factory was built at the south end of Main Street and was purchased in 1884 by C. Frank Floyd and George J. Olney Sr. Country life moved along with the seasons coming and going, and then in 1903, everything changed. The voters of the state of New York passed a bond issue to enlarge and improve the Erie Canal. To improve the canal system, a more reliable source of water was needed. To achieve this, the state needed to build five reservoirs, with one being on the Mohawk River at a set of cliffs, near the village. As surveyors and engineers descended on the village, the residents began to realize that their village was doomed. As the workers and construction equipment began to arrive, they soon came to realize all was lost. Blue evacuation notices were served, and the people began to move away; many tears were shed and hearts were broken. As the village was razed, trees cut down and the miscellaneous burned, a haze hung over the village for weeks, and it was a very sad time. Within four short years, the impounding dam was finished and the farmland began to flood. Former residents stood on the surrounding hills and watched as the location of their former homes and farms became the floor of the new reservoir. Today Lake Delta is a beautiful place that people have come to enjoy and love.

One

DELTA, THE PLACE

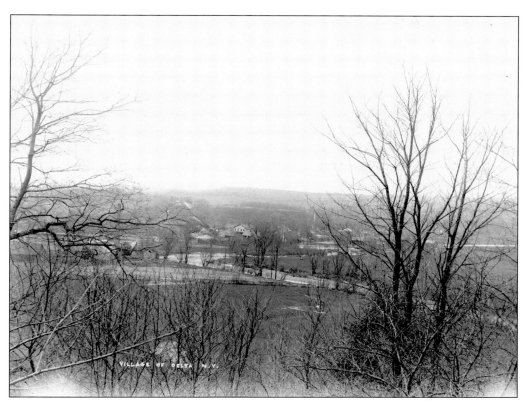

How did Delta get its name? According to popular folklore, Capt. Gates Peck said that if one stood on the hills and looked at the bend in the river and drew an imaginary line across the bend, one got the letter *D*, and translated to Greek, one got Delta. Based upon the suggestion of Peck, the villagers choose the name Delta, and a post office was established.

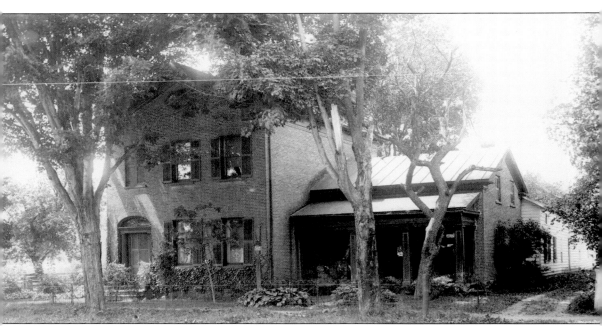

The lovely brick home of William Dennison was located on the west side of Main Street across from the brick store. Richard Catlin had this home built in 1833 by the Byam brothers of the town of Lee. The bricks, from clay obtained from the nearby riverbanks, were burned in the courtyard. The Dennison family came from New London, Connecticut, being early settlers of the town of Floyd and later moving to the village. The farm came to be known as Spring Brook Farm because of the many springs on the property. The Dennison property was the first to be taken by the state for the new reservoir. This was because it needed the excellent woodlots on the property to start construction at the dam site. After being forced to leave Delta, the Dennisons moved into a brick home on West Thomas Street in Rome. (Courtesy of Andrew Smith.)

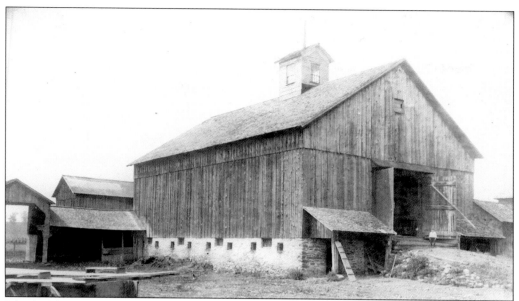

The building improvements on Spring Brook Farm were some of the finest in the area. This great barn, built in 1863, measures 150 feet by 40 feet and is one of the finest in the town of Lee. (Courtesy of Andrew Smith.)

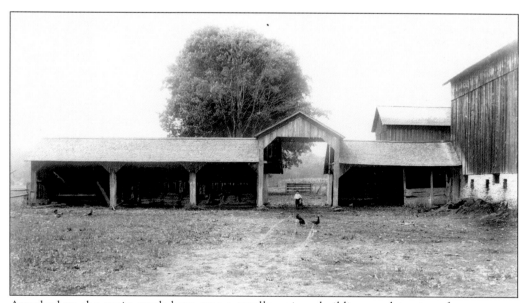

Attached to the main stock barn was a totally unique building used to store farm wagons, carriages, and sleighs. The center drive-through allowed access to the fertile farmlands and pine and cedar forests beyond. The farm was dotted with many outbuildings, including an icehouse, chicken coop, and storage buildings. (Courtesy of Andrew Smith.)

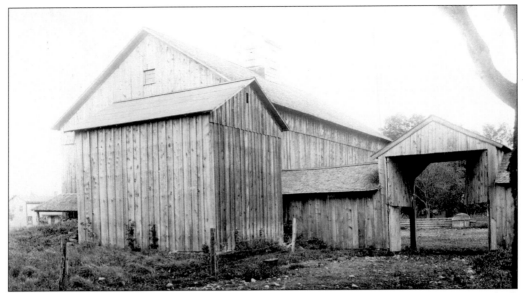

This is a rear view of the main barn with the drive-through shed and another large barn attached. In an 1880 newspaper article, it was reported that a driving park had been established at the Dennisons' Spring Brook Farm; it is possible that this park was located in the meadows behind this barn. (Courtesy of Andrew Smith.)

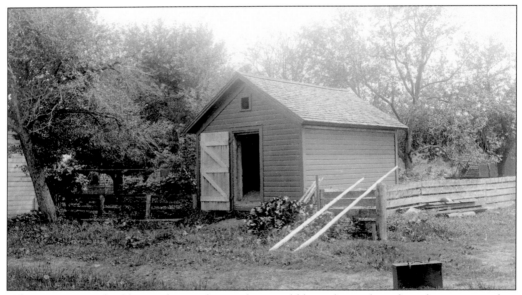

What a nice neat building to house the ice that would be welcomed on those hot summer days in the Dennisons' kitchen. The ice was used to help make the ice cream served at the numerous ice-cream socials. This picture was taken in late summer, so maybe the ice was gone and the building was being aired out. (Courtesy of Andrew Smith.)

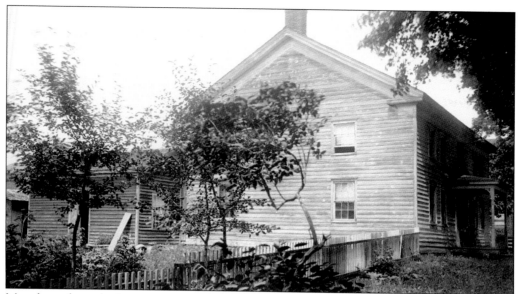

Most large farms had a tenant or overseer's house. This house was built by Israel Stark and at one time was the home of C. E. Fraser. The farm changed hands several times before becoming part of Spring Brook Farm. The farm had a fine dairy, many orchards, and fertile soil. (Courtesy of Andrew Smith.)

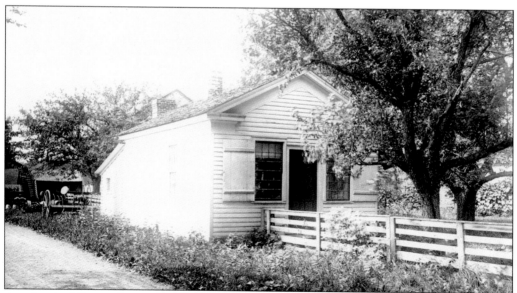

Another building on Spring Brook Farm was this lovely shop building where farm business may have been conducted or where farm implements and other items may have been repaired. It was another of the well-maintained buildings on the farm. (Courtesy of Andrew Smith.)

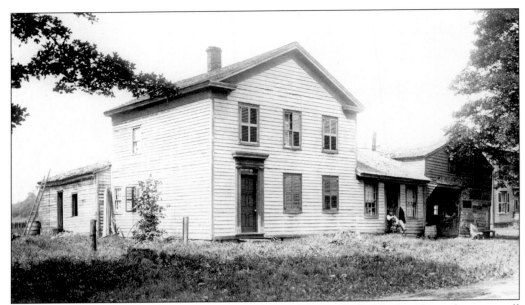

This home at one time belonged to Alexander and Lavanda Paddock. Alexander was well known in the area and operated a livery stable from the barn north of the house. He rented well-groomed horses and good buggies to whomever needed them. His livery business improved when he owned and operated the local hotel. (Courtesy of Andrew Smith.)

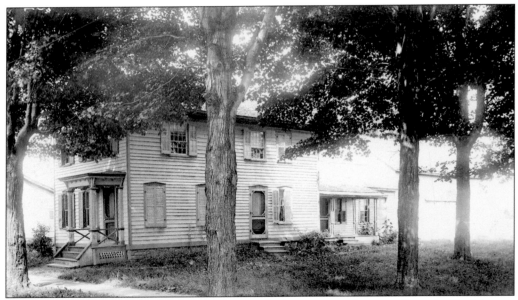

Alfred and Sophronia Utley lived in this home, which was across the street from the Dr. Johnson Pillmore residence on Main Street. The property belonged to Pillmore, who rented the home to his wife's parents. Several days before leaving this home, Alfred died of a heart attack. (Courtesy of Andrew Smith.)

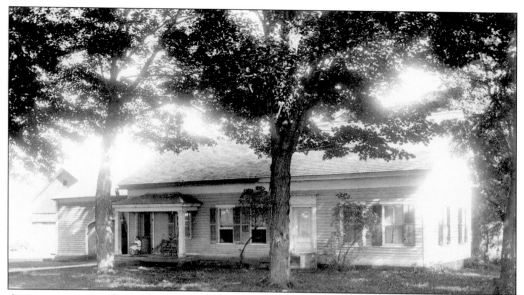

As one went over the bridge crossing the Mohawk River, not far from the Black River Canal feeder, one came to the farm of John T. Ragan. The Ragans had lived on the farm for over 40 years until the state took the property. John and Mary Smith Ragan had three sons and one daughter. (Courtesy of Andrew Smith.)

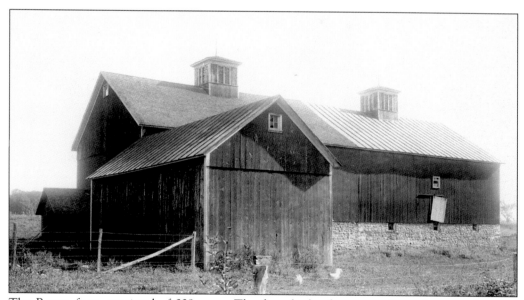

The Ragan farm consisted of 229 acres. The farm had a few acres of meadows on the river flats and access to these meadows by a bridge over the feeder. This well-kept barn was built in July 1887 and was used until taken by the state. It must have been heartbreaking to leave this great barn and know it soon would be gone. (Courtesy of Andrew Smith.)

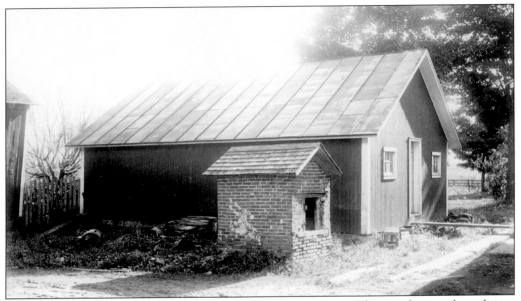

The chickens on the Ragan farm lived in a nice house. It was well kept and in good condition. This photograph gives a view of a brick springhouse, with the opening facing the main house. When the lake goes down, the debris fields in this area are littered with bricks, along with cobblestone foundations. (Courtesy of Andrew Smith.)

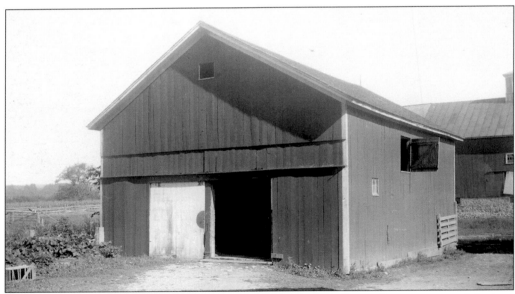

The meadows roll out behind this barn toward the hills. The Ragan farm was one of the best in the area. In 1897, it was reported that a fine crop of rye was raised on 11 acres of the farm. The rye was heavily headed and standing an average of seven to eight feet tall. (Courtesy of Andrew Smith.)

The Edward Rudd farm residence faced south and across the highway from the Black River Canal feeder. This 122-acre farm consisted of a large number of acres in meadowlands as well as many acres of fertile tillable soil. Edward was the son of Prosper E. Rudd and was married to Augusta J. Jones, and they had two sons. (Courtesy of Sylvia Kahler.)

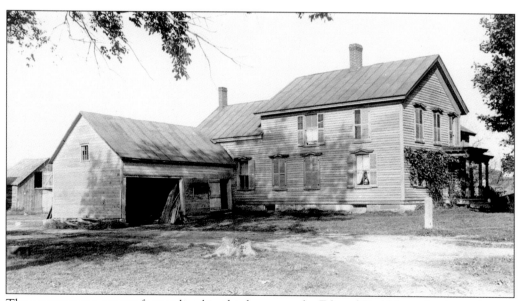

The overseer or a tenant farmer lived in this house on the Edward Rudd farm. In those times, a tenant farmer could rent a portion of a large farm and till the soil for the season and then move on. This house may have been the original home that Prosper E. Rudd built when he first came to the area. (Courtesy of Sylvia Kahler.)

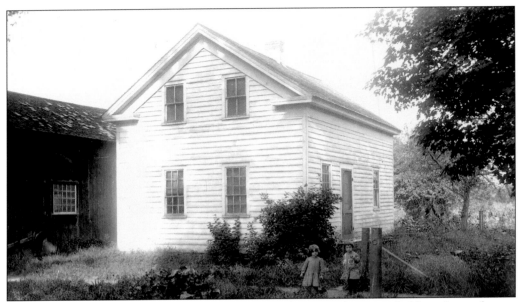

Charles Bathrick came to Delta in 1894 to make cheese in the second-oldest cheese factory in the United States. He was a master cheese maker and stayed at the factory for 14 years. He married the daughter of Lawrence Corr. (Courtesy of Andrew Smith.)

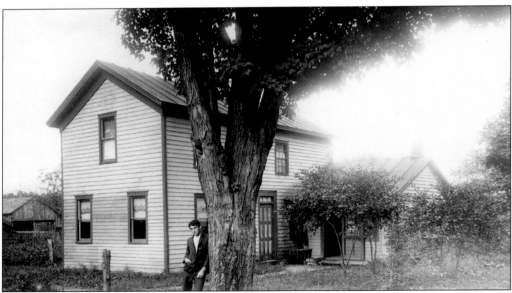

Charles Albott retired to this house in 1855 after returning from California, where he hunted big game and mined for gold. Albott was born in 1820 in England and graduated from Upshaw College. He came to the United States in 1842, settling in the town of Western. He was well liked, and his local nickname was "Prince Albott." (Courtesy of Andrew Smith.)

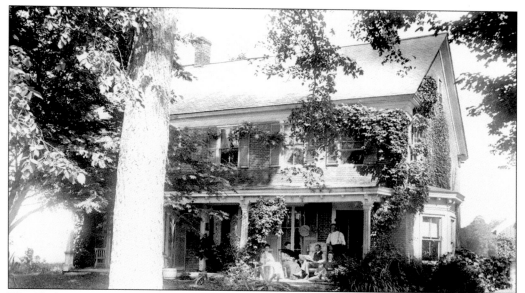

The Elisha Walsworth homestead, a local landmark, was pleasantly located and faced south. The grand old farmhouse was in the family for over 100 years and was built from bricks burned in the dooryard. The road leading to the old farmhouse was lined with maple trees, creating a pleasing effect. (Courtesy of Andrew Smith.)

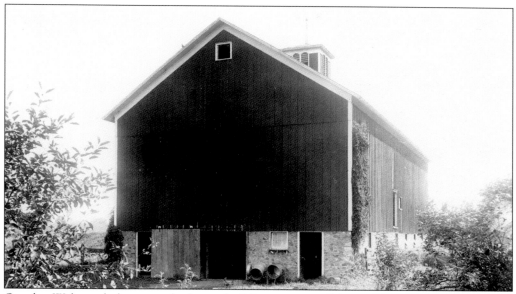

On the Walsworth homestead, the outbuildings were well kept. This spacious barn is an excellent example of the great barns located in the Delta area. It had a sturdy rock foundation of local stone. Completing the barn was the shuttered cupola that helped ventilate the hayloft. (Courtesy of Andrew Smith.)

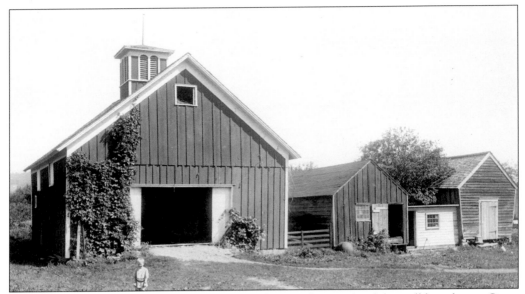

The Walsworth horse and carriage barn is another good example of the well-kept barns. Since horses were highly valued, their owners took great care in sheltering their source of labor and transportation. Notice the lightning rod on top of the cupola. (Courtesy of Andrew Smith.)

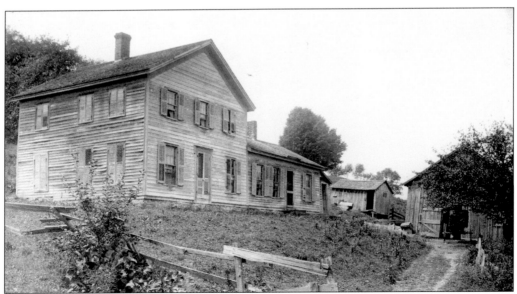

Elizabeth Eldred owned this older home that was built in the very early days by Israel Stark. Eldred at one time owned the old cheese factory buildings. She and her husband were master cheese makers, and they traveled up and down the East Coast teaching the art of cheese making. They returned to their home at Delta each winter. (Courtesy of Andrew Smith.)

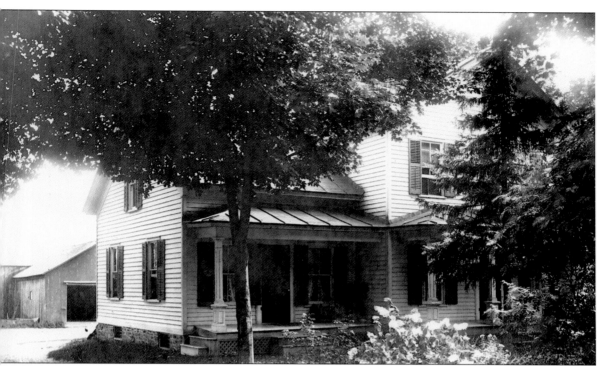

The Kettle Hill Farm was owned by William Vincent Evans and located at the foot of an area called Pettibone Hill. William Vincent and his new bride, Mary Jones Evans, were married on May 21, 1847, in Wales. For their wedding trip they sailed to America to begin their new life. Around 1850, they settled on the hills above the Mohawk River and the Delta area. The original homestead was built on top of Pettibone Hill. William Vincent then built another house at the foot of the hill closer to the Mohawk and moved his family there. Later he built a new home closer to the old River Road. The home was protected from the weather by the hills on the north and west. It had an abundant water supply from a nearby spring that flowed through a ravine to join the Mohawk River. The old farmhouse had stood for many years when it was finally taken down. The Kettle Hill Farm had many acres of lowlands near the Mohawk and some meadows on the hills above. William Vincent and Mary had many hands to help operate the farm, for they were the parents of seven sons and one daughter. (Courtesy of Andrew Smith.)

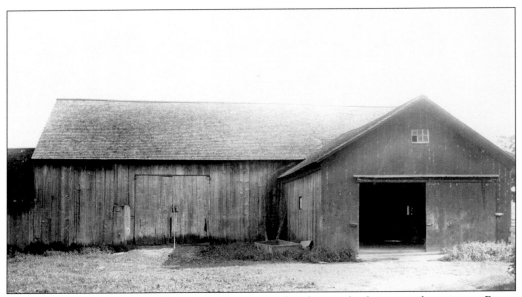

Near the Evans house was this barn that was used to house the horses and carriages. Barns of that era served many purposes and were well kept. Several other barns were built into the hillside to use the land to its best advantage. (Courtesy of Andrew Smith.)

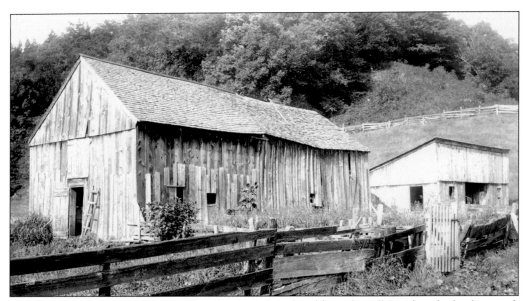

The most interesting thing about this photograph is the old Kettle Hill Road in the background. The road weaves its way down and around and passes the famous kettle and goes up the side of the steep ravine that was part of the Evans farm. These barns were part of the original farm buildings. (Courtesy of Andrew Smith.)

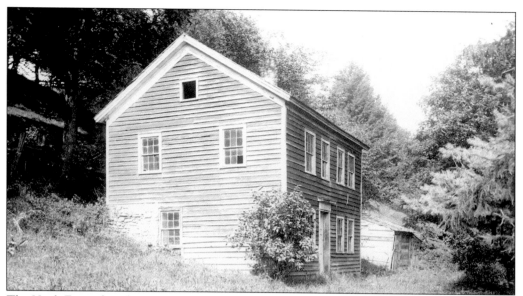

The Hugh Evans farm home was located in the Kettle Hill area; the old road can be seen behind the house in the shadows. Evans retired from farming and moved to Main Street in Delta, leaving the house empty until it was taken by the state. (Courtesy of Andrew Smith.)

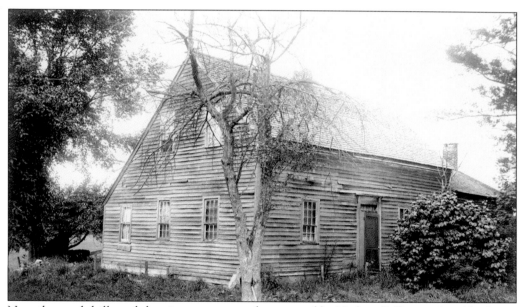

Near the south hills and the pine grove was a farm owned by Nathan Bellinger. An older home from the early days was occupied by Nathan and his two daughters, Jennie and Mary. Nathan was a descendent of Col. Frederick Bellinger, who was killed during the Revolutionary War at the Battle of Oriskany. (Courtesy of Andrew Smith.)

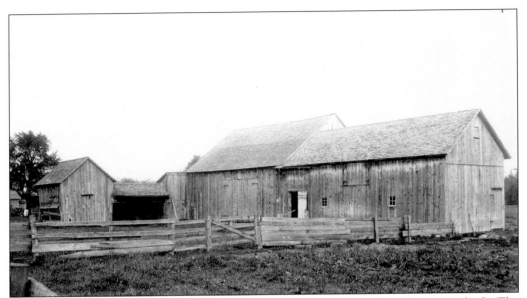

The Bellinger farm was prosperous with a number of barns, corncribs, and storage sheds. The farm consisted of 68 acres where the usual soil products were raised and where a good dairy herd existed. The farm also had some nearby woodlots where the wood was cut for heating or sold to the sawmill. (Courtesy of Andrew Smith.)

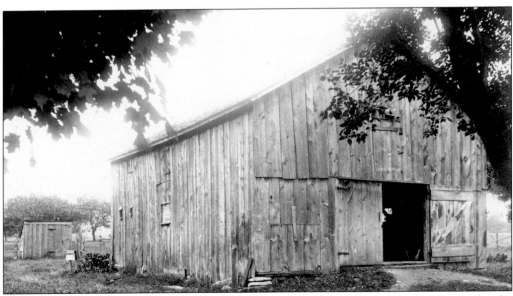

Behind the house was the horse and carriage barn were the means of transportation for the family were housed. Inside the barn there may have been a workshop and tool storage. It is an old barn that seems to lean somewhat. (Courtesy of Andrew Smith.)

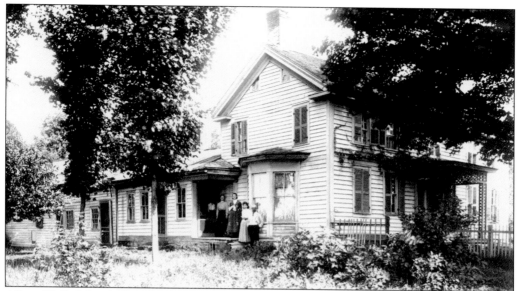

Albert Bielby's lovely farm home was located near lock No. 13 of the Black River Canal, on the highway from Westernville to Delta. The house with its nice front porch appears to be spacious and comfortable. The farm, once known as the Noah Wilson farm, had numerous meadows and good tillable lands. When Bielby and his wife were forced to move from Delta, they located on Turin Road near present-day Bielby Road. (Courtesy of Andrew Smith.)

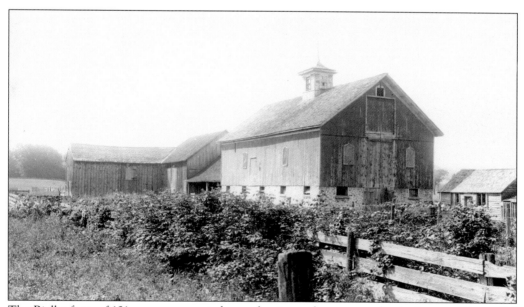

The Bielby farm of 121 acres appears to be productive and prosperous by the large and beautiful barns that were located on the farm. The foundation of local stone appears to have been whitewashed. The barn cupola was not only used for decoration but for ventilation of the hayloft. (Courtesy of Andrew Smith.)

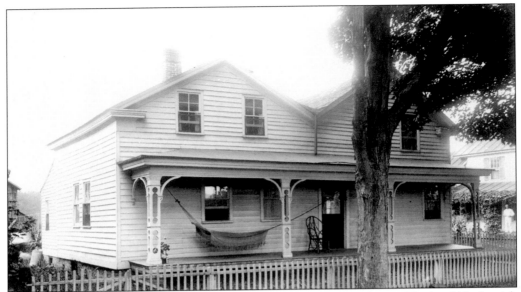

George McIntosh lived in the village for over 30 years and conducted one of the local blacksmith shops. His shop was just down the street from his home, which was located on the west side of Main Street near Short Street. The nice front porch looks inviting with its hammock and chair. (Courtesy of Andrew Smith.)

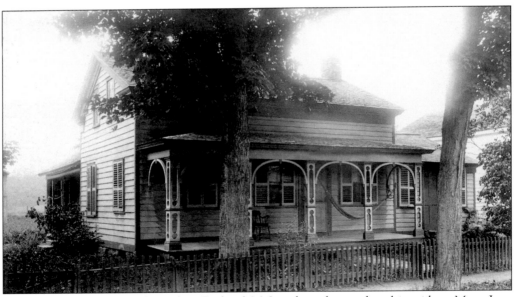

This nice small house belonged to Richard McIntosh and passed to his widow, Mary Jane Westcott McIntosh, upon his death in 1899. This home was several doors down the street from George McIntosh's on the same side of the street. Mary Jane lived here until the property was taken by the state. Mary Jane died in 1925 at the age of 81. (Courtesy of Andrew Smith.)

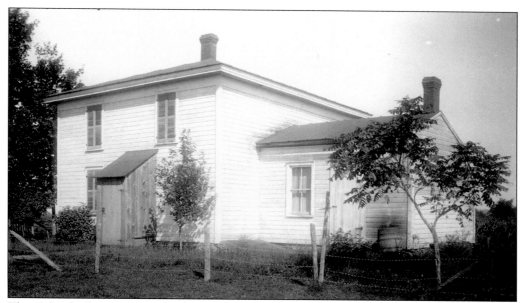

The Palisade Farm was settled by Gurdon Hurlbut. The farm was named in honor of the magnificent palisades across the valley from the farm. The residence was newer, having only been built a few years before this picture. The house was not taken by the state because it set on high ground overlooking the palisades. The original farm contained 85 acres. The main industries of the farm were a dairy and soil products. On the meadowland is where the state chose to build the new impounding dam between the east and west palisades. (Courtesy of Andrew Smith.)

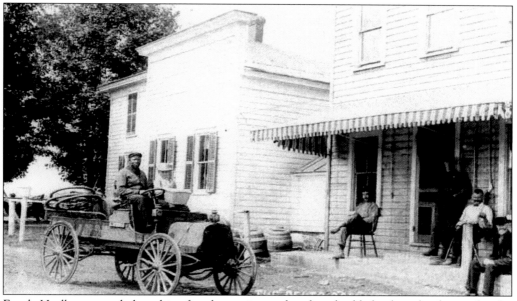

Frank Hurlbut turned the white farmhouse into a hotel and added a boardinghouse for the workers at the construction site. Notice the original house in the background to which a facade was added. The man in the car is Monroe Harris, a driver for the McMullin Construction Company, which was building the new impounding dam.

In the background can be seen the palisades and in the upper right corner some rapids of the Mohawk River. This building set atop the west palisade, where it would be replaced with a retaining wall for the new reservoir. This photograph should be called "a room with a view." (Courtesy of Andrew Smith.)

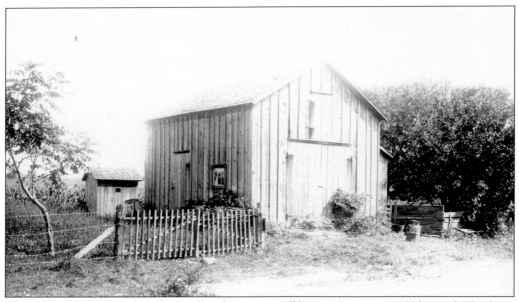

The outbuildings located on the Hurlbut farm were well kept and conveniently located. This barn and other outbuildings were not taken down but used by the state during the dam construction. Frank Hurlbut married Lucy E. Duyette of Oswego County, and they had 10 children. (Courtesy of Andrew Smith.)

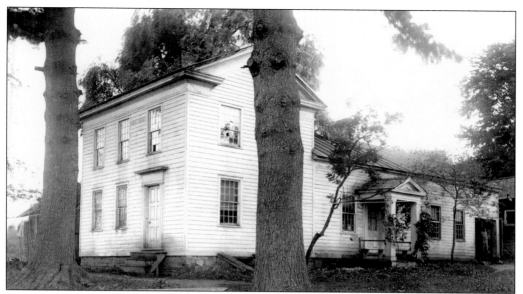

Just past the Israel T. White farm as the old River Road meandered along the west side of the Mohawk River toward Westernville, the road passed the Cheslar Pillmore farm. Parts of the old foundations of this farm can still be seen along the north shore of the lake. (Courtesy of Andrew Smith.)

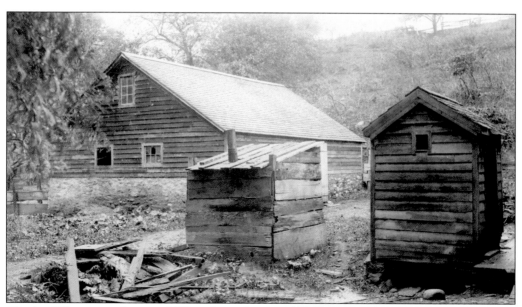

Cheslar Pillmore was born in 1878 and was the son of William F. and Louisa Stahl Pillmore. In 1906, he married May M. Smith, and they shared a happy union of 40 years. These barns served the farm well, with the larger barn's foundation built of local fieldstones that appear to have been whitewashed. (Courtesy of Andrew Smith.)

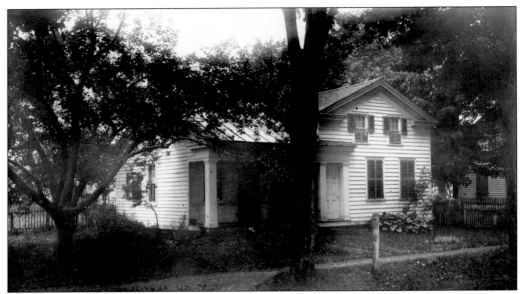

Centrally located on Main Street across from the bridge spanning the Mohawk River was the home of Andrew Sly and his sister Eliza, who had been living here since 1885. Their parents were Adin and Alma Arnold Sly, natives of Massachusetts who settled in the town of Lee in 1827. When they were forced to leave Delta, they moved to Lee Center. (Courtesy of Andrew Smith.)

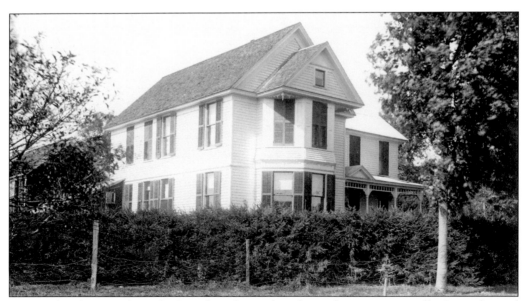

Not much is known about the David Anderegg farm located near Westernville. It was located at the end of a short dirt road that passed the Mohawk Valley Canning Company. The farm contained 61 acres on the banks of the Mohawk River. This is an impressive home with a porch to the side and bay windows on both floors. (Courtesy of Andrew Smith.)

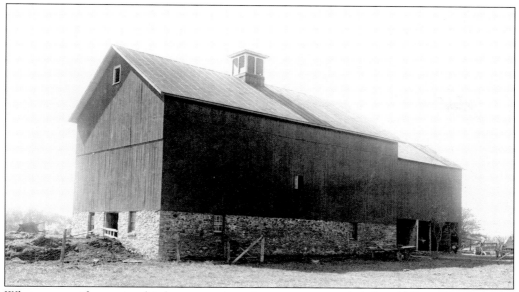

What a magnificent site this barn must have been as one traveled the old River Road toward Westernville. It was another of the well-kept barns of the area with a fieldstone foundation and cupola. (Courtesy of Andrew Smith.)

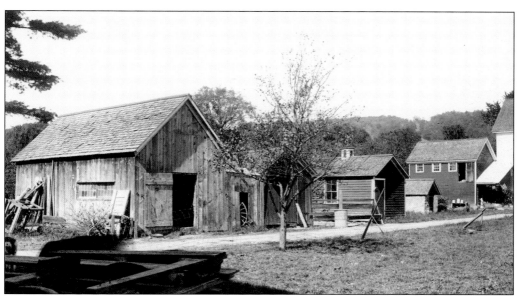

This farmyard was between the main barn of the Anderegg farm and the house. There appears to be a horse barn, a chicken coop, and storage sheds. All the buildings appear to be in good condition. Also located on the farm was a sawmill. (Courtesy of Andrew Smith.)

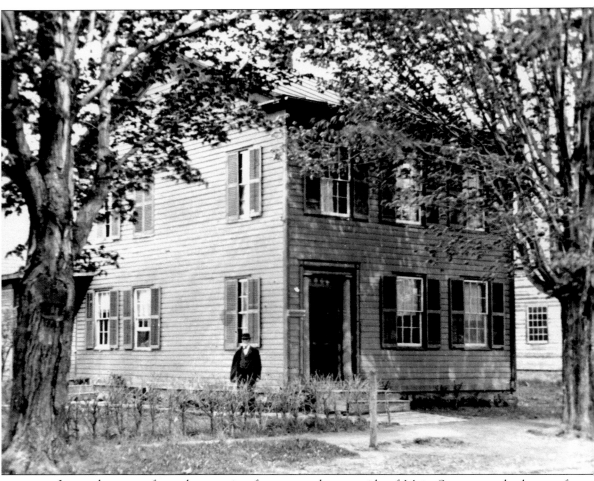

Just a short way from the canning factory on the east side of Main Street was the home of Dr. Johnson Pillmore, who served the needs of the valley. The home appears to be spacious and comfortable. Pillmore kept his office on the south side of the building. Behind the house was a huge vegetable, herb, and flower garden. One herb grown was ginseng, an old-time remedy. He kept his honey bees down on the banks of the Mohawk River. Pillmore had been appointed the physician for the construction project and was told his family would be the last to move from the destroyed village. After his death in 1910, his wife Mary June and children moved to Rome. The Pillmore house was dismantled and moved by horse and wagon to Glenmore Road in Taberg.

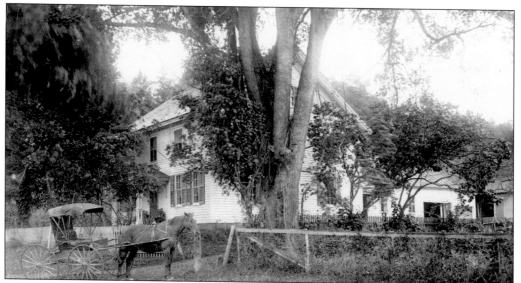

As the old River Road goes along from Kettle Hill, the road turns and goes down a short narrow ravine; coming out of the ravine on one's left is the homestead of Israel T. White. This lovely house sat at an angle to the road and steep hills. Note the large tree at the corner of the driveway near the fence. In certain years, when the lake is low, the tree stump becomes visible. (Courtesy of Andrew Smith.)

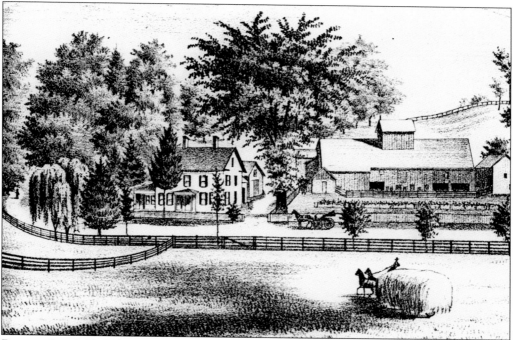

Deacon Israel T. White was a prominent and well-known member of the Westernville Presbyterian Church and a founding member of the Westernville Farmers Fire and Lightning Insurance Company. One of his favorite pastimes was playing chess with Dr. Johnson Pillmore. (Courtesy of *Oneida County Atlas*.)

A truly unique barn existed on the White farm. It is ingenious the way this barn was built to fit into the hills behind it. The builder used the land to its best advantage. The barns of that era were used for many things as this one probably was. The rocks from the foundation can still be found on the lakeshore. (Courtesy of Andrew Smith.)

This barn on the White farm may have been used for storage of hay or grains. The barn was built along the edge of another narrow ravine located on the farm. Notice the block and tackle system on the front of the structure. The big rocks to the right are still there today in the narrow ravine. (Courtesy of Andrew Smith.)

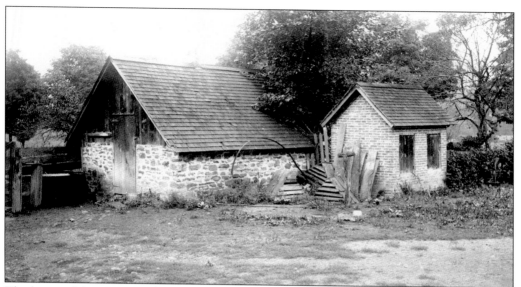

The larger of the two stone buildings could be an icehouse, where ice blocks from the Mohawk River were stored for future use. The smaller of the two could have been a smokehouse or springhouse. The springhouse was used to cool fresh milk and store butter. There was no cheese factory on this farm. Bricks and stones from these buildings still litter the lakeshore today. (Courtesy of Andrew Smith.)

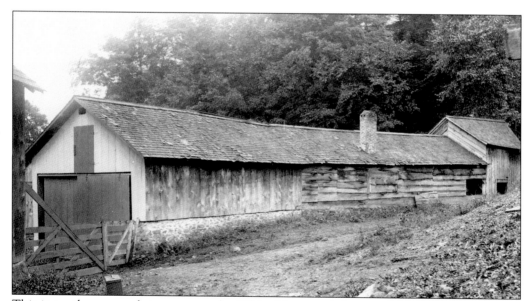

This is another unusual structure on the Whites' farm, and the use is unknown. It could be a horse barn, pigsty, or shop because of the chimney. It is another barn of the era that served many purposes. (Courtesy of Andrew Smith.)

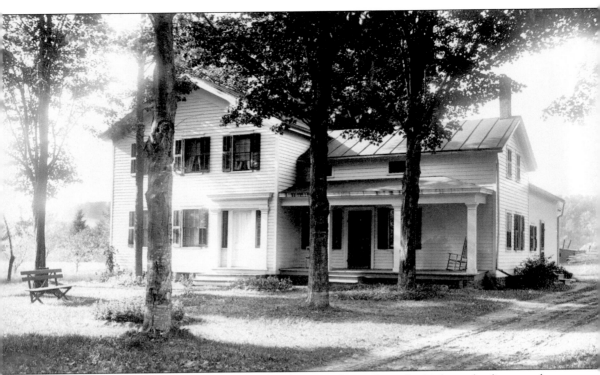

The prosperous farm of the Teuscher brothers was located on the highway leading northeast from Delta toward Rome. It was across the Mohawk River from the White farm. The farm consisted of 150 acres that rolled out on the east bank of the Mohawk River. The brothers, John and Jacob, from Berne, Switzerland, immigrated to the area in 1889. They purchased the former Albert Arnold farm and lived there with their sister Alice until 1910, when the land was taken for the new reservoir. The brothers then bought a 193-acre farm in Wright Settlement near Rome. In 1941, when the Rome Army Air Field (Griffiss Air Force Base) was being developed, their new farm was taken to be incorporated in the new airfield. The Teuscher brothers' farm was one of the best in the area with a well-kept farmhouse and outbuildings. (Courtesy of Andrew Smith.)

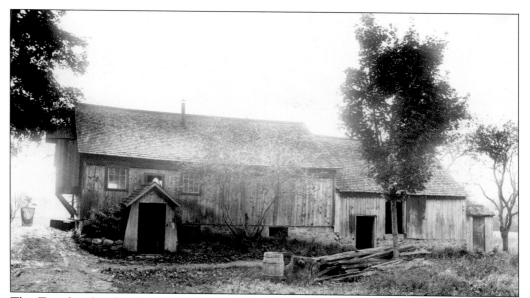

The Teuscher brothers had an on-site cheese factory where they utilized some of the milk produced from their cows to make cheese. In this factory, the production area was on the first floor and a dry house to age the cheese above. Cheese was an important commodity because it could be sold for profit. At one point, this cheese factory was leased to a national cheese manufacturer. (Courtesy of Andrew Smith.)

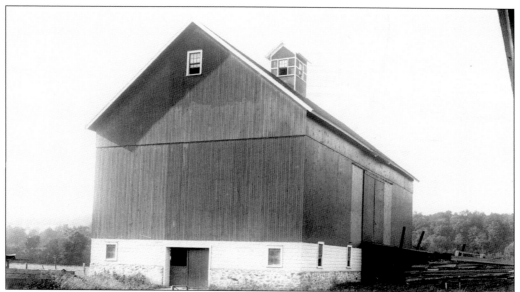

The land around the Teuscher brothers' stock barn appears to be flat but it did roll toward the Mohawk River in front of it. What an excellent structure with a whitewashed stone foundation and painted window frames. It must have been sad to watch this magnificent barn be torn down. The farm had an excellent dairy herd and raised the usual soil products. It also had a fine apple orchard. (Courtesy of Andrew Smith.)

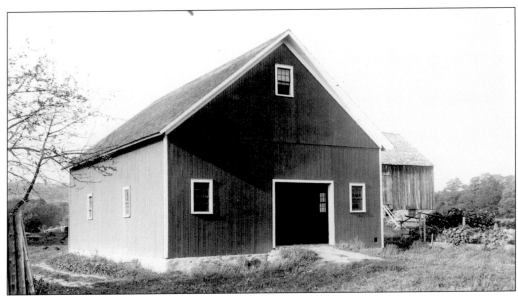

Located behind the Teuschers' farmhouse, the carriage barn was the place to store the buggies and sleighs. The favorite horse or horses were also housed there. Notice the clean features of the structure nicely outlined by white paint. The barn is modern in its appearance; one would expect to find it on a present-day farm. (Courtesy of Andrew Smith.)

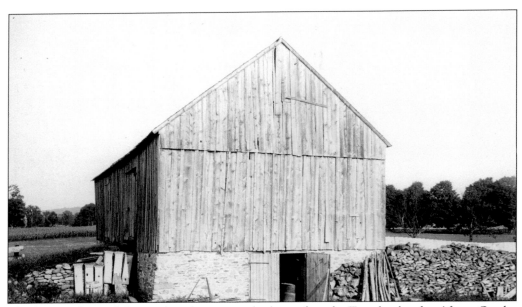

This barn with its solid stone foundation was also located on the Teuscher brothers' farm. On the right side is a long pile of cordwood. As the barns on this farm were torn down, the foundation stones were being salvaged and piled into a huge pile that still exists today. This rock pile is a hazard to careless boaters in the late summer. (Courtesy of Andrew Smith.)

The last farm located on the lower south highway that ran from Delta to Rome was the home of Frank Potter. The farm home was built on a rise of ground that swept toward the highway. Frank was the son of George B. Potter and married a daughter of George Tuthill. (Courtesy of Andrew Smith.)

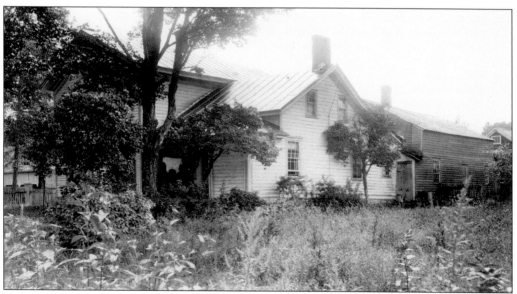

A short distance from lock No. 13 of the Black River Canal was the John Harris farm. Abby French, sister of John, and her daughter Susan resided with John, who never married. In 1910, when the farm was taken, they moved to Westernville. John lived to be over 90 years old, and Abby lived to be 103. (Courtesy of Andrew Smith.)

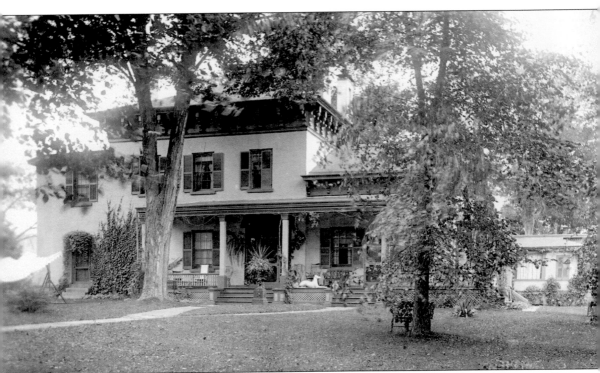

This magnificent home was located at the south end of Main Street in the village of Westernville. The home was one of the historical farms of the town of Western. Henry Wager came to the area as a 17-year-old in the 8th Albany Regiment under the command of Col. Philip Van Rensselear. The regiment was dispatched to the Mohawk River to support Col. Marinus Willet at Fort Stanwix. Wager was much impressed with the richness and potential of the area. He returned in 1792 as one of the early settlers of the town of Western, taking up 500 acres of land. Between 1812 and 1814, he had this impressive brick and brownstone home built on a rise overlooking the surrounding area. Wager and his wife, Viletta (or Lettie), raised their family in this lovely home. Wager was very influential in the politics of the town, serving as supervisor for over 25 years. He lived in this home for over 50 years until his death. The home passed to his son Henry Wager Jr. and finally to his granddaughters Charlotte and Harriet Wager.

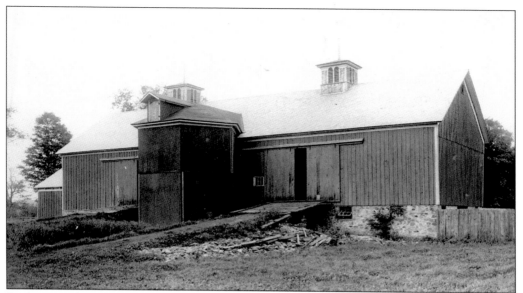

By the time the state took the land, the Wager farm contained 270 acres. A fine herd of cows was housed in the bottom half of this barn. Note the unusual shape of the silo, almost an octagon. The farm had several orchards where apples, pears, and cherries were grown. The Mohawk River and many springs flowed through the farm, giving it an excellent source of water. (Courtesy of Andrew Smith.)

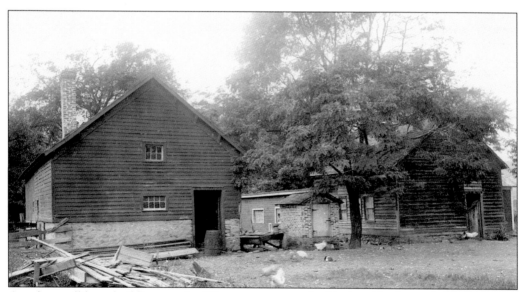

Another well-kept building on the Wager estate was the blacksmith shop, where the horses were shod and farm implements manufactured. Next to the shop can be seen a small brick building that was either a springhouse or a smokehouse. Note the chickens happily pecking and scratching in the foreground. (Courtesy of Andrew Smith.)

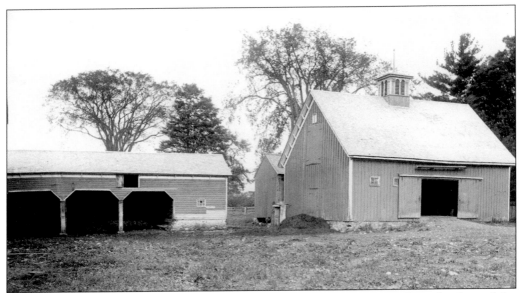

A carriage barn and horse barn appear side by side on the Wager estate. Over the door of the horse barn was a wooden rain gutter to disperse the rainwater. This barn had a nice cupola for ventilation and a lightning rod for protection. The carriage barn seems to have been under repair when this picture was taken. (Courtesy of Andrew Smith.)

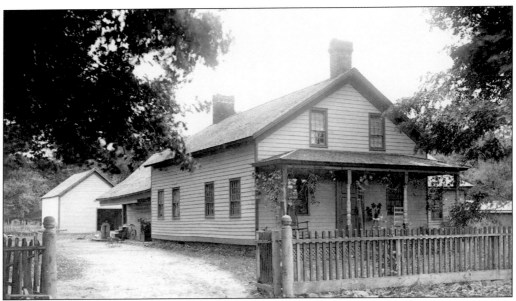

When the roads that went from Westernville to Delta and Rome met, they formed a crossroads that was called Wager Corners. On the right side of the road was the Wager estate, and on the other corner was the Wager tenant house and barn. For many years, the house was occupied by Kendrick Samson. Close to this crossroad was the Black River Canal. (Courtesy of Andrew Smith.)

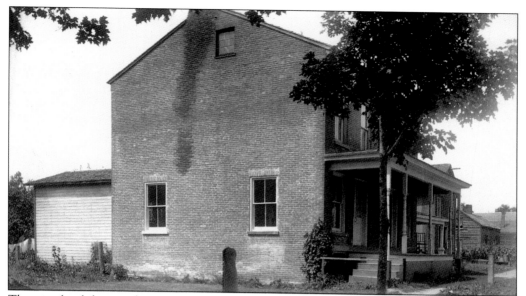

The nice brick home of Marion Bushnell (M. B.) Smith was located on the west side of Main Street across from the Empire Hotel. Smith and his family came to the village in 1891 when he purchased the gristmill. After leaving the village, the family moved to Westmoreland. (Courtesy of Freida Royal Smith.)

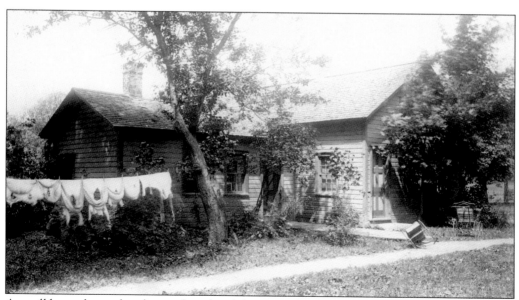

A small house located at the north end and the west side of Main Street near the District No. 17 school was the home of Ebenezer Watson. It was an older home built in the early days of Delta. The weekly laundry is hanging out to dry on this early-fall day. (Courtesy of Andrew Smith.)

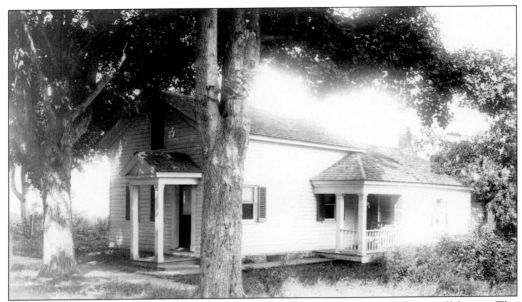

Not much is known about Charles Brown and his family, who lived in this small home. The home, on the east side of Main Street, had a side porch that went to the kitchen area and was across from the Methodist church parsonage. (Courtesy of Andrew Smith.)

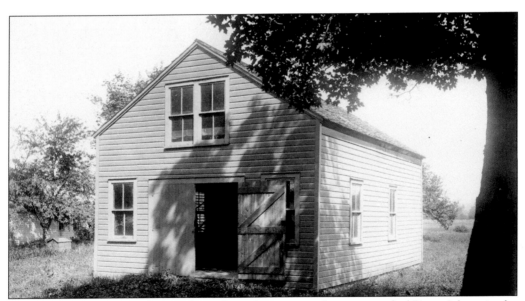

With its double-hung windows and wooden siding, one might expect to find Brown's barn in the countryside today. It was a well-kept structure that appears to be painted gray with white window trim. Also located on the property were a smaller barn, corncrib, and henhouse. (Courtesy of Andrew Smith.)

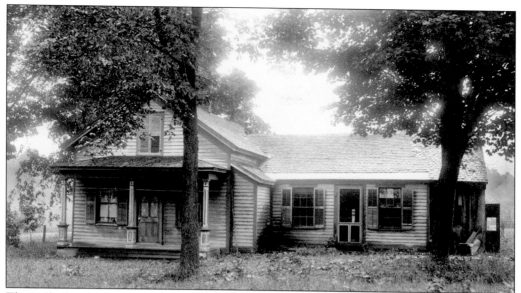

This is the last house on the east side of Main Street going north out of the village. Lester Brown and his wife enjoyed life here. Brown was the first Delta resident to buy an automobile. Everyone knew when the Browns were coming down the street as the automobile had no muffler, and they would rush to their windows to see the new contraption pass by. (Courtesy of Andrew Smith.)

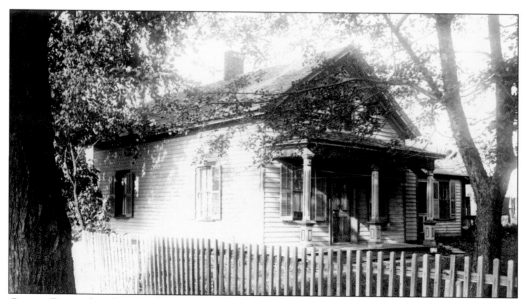

George Brown lived in this home on the east side of Main Street. Brown was a local handyman and took care of the village green. He may have been a descendant of the slaves that Henry Wager Sr. or Gen. William Floyd brought to the area. (Courtesy of Andrew Smith.)

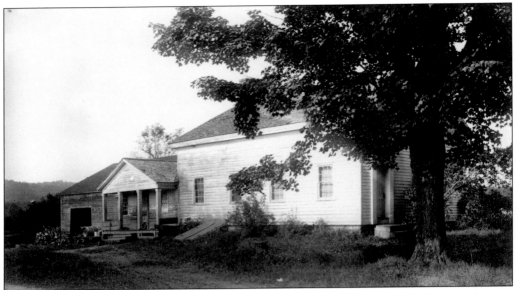

The Brayton and Parmalee farm was located close to Westernville. The tenant house was located near the end of Main Street, while the main farm home was located in the village. Of this farm, the state took only 40 acres. The Braytons were early settlers of the town and operated a general store. The Parmalees were prominent in the town, with one being the Presbyterian minister. (Courtesy of Andrew Smith.)

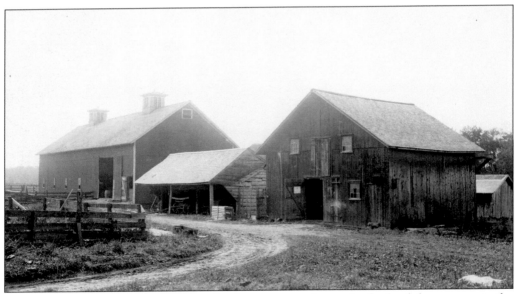

These barns on the Brayton and Parmalee farm appear to be on the flat land that ran out to the Mohawk River behind. The farm grew the usual soil products of potatoes, corn, oats, and wheat. The farm had orchards and gardens across the street. (Courtesy of Andrew Smith.)

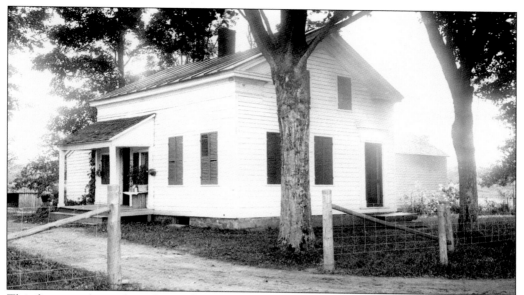

This farm was located on the road that ran from the Black River Canal feeder toward Wager Corners and Westernville. When the land was taken by the state, Charles and Libbie Brown Clark were living there. The state had the farm belonging to the Ezra Clark estate, but local records have Charles and his family living there. (Courtesy of Andrew Smith.)

The Clark farm of 33 acres was about a half mile from the Mohawk River; one can see the river flats behind the barn. The farm raised the usual soil products including hay and grains. There were several other small barns on the farm. Not much is known about the family, except Charles died in 1914 and Libbie in 1934. (Courtesy of Andrew Smith.)

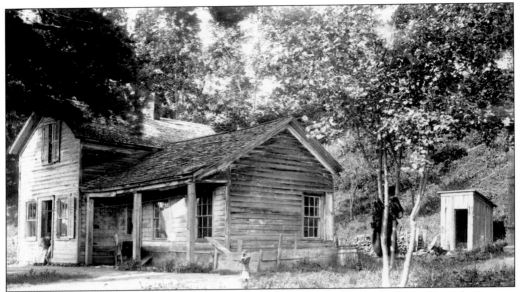

The Seth DeForest home was located on the road that ran north out of Delta to Daniels Corners (present-day Stokes Cove). It appears to be one of the early homes. The home appears to be run-down but lived in. There is laundry hanging on the porch. Note the outhouse with no door. (Courtesy of Andrew Smith.)

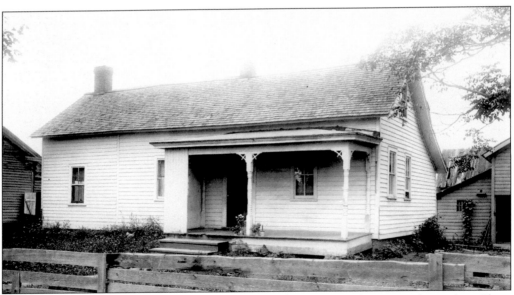

A small nicely kept house with a front porch, the William Dorr home was located on Short Street, which ran beside the McIntosh blacksmith shop. The Dorr family attended the local church and participated in many events. Helen Dorr was a close friend of Mary June Pillmore. (Courtesy of Andrew Smith.)

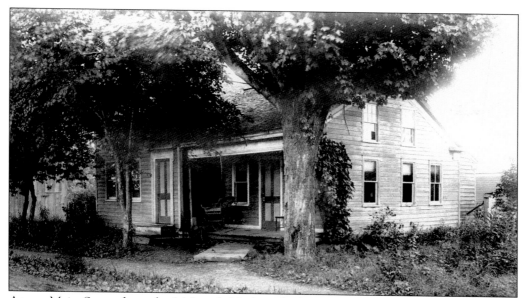

Across Main Street from the McIntosh blacksmith shop was one of the older homes in the village setting on an original village lot laid out by Israel Stark. The house was probably built prior to 1830. Leon Hubbard and his wife were living in the house when it was taken by the state. (Courtesy of Andrew Smith.)

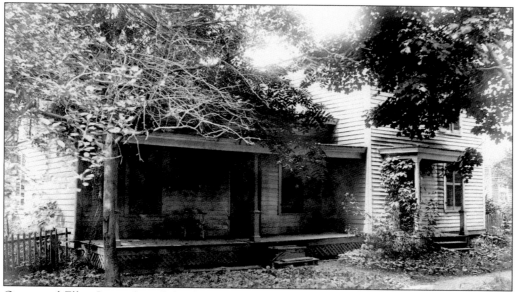

Owen and Ellen Jones shared this home located on the west side of Main Street. The family lived in Delta for over 20 years. Here in this home they raised their family of five sons and four daughters. Ellen Jones died in September 1905, a few days short of celebrating her golden wedding anniversary, commemorating a marriage of 50 years. (Courtesy of Andrew Smith.)

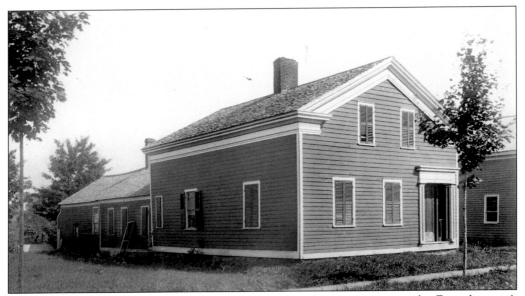

Next to the John Ernst general store on the east side of Main Street was the Ernst home. A well-kept, modest home with a kitchen wing and woodshed to the rear, this home was the last structure to be torn down, and a picture documenting this fact appeared in the *Utica Globe*. Cora Harrison helped Jeannette Ernst pack the family's belongings for the move to Stokes Corners. (Courtesy of Andrew Smith.)

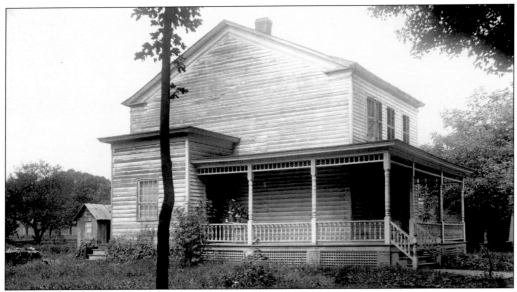

Another of the original older homes of the village, the George Platt home was next door to the Owen Jones home on Main Street. Platt was a 40-year employee of the Olney and Floyd canning factory. Born in 1859, the son of Joseph and Jane Snodgrass Platt, he married Felicia Forgeon in August 1883. (Courtesy of Andrew Smith.)

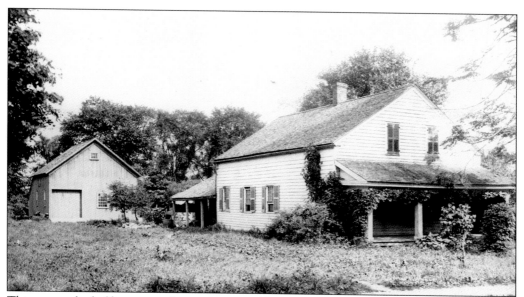

This one-and-a-half-story wood structure owned by George Winchell was located on the eastern corner of Main Street and the road that led to Westernville. It was a comfortable home with a shady front porch and utility porch attached to the rear. The horse and carriage barn can be seen to the back of the one-third acre of land. (Courtesy of Andrew Smith.)

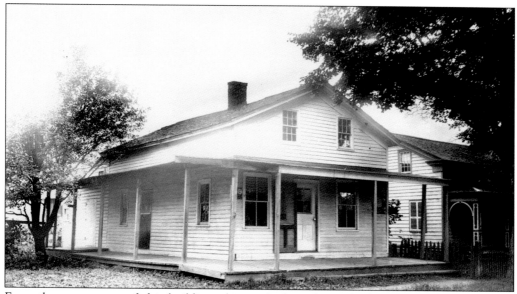

From the appearance of this building, this might have been the location of a general store Jackson Clark opened after the stone store burned. The wide front porch was for the display of goods, and advertising signs are still nailed by the front door. Clark owned several parcels of land in and around the village. (Courtesy of Andrew Smith.)

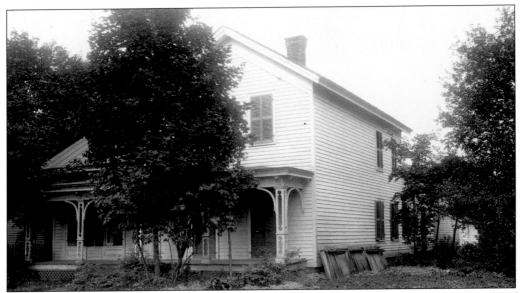

The death of Jackson Clark occurred in September 1903 at his residence on the west side of Main Street. This lovely home then passed to his wife, Francis Harter Clark. Jackson was an entrepreneur who operated the old stone store. After the store burned, he then traveled the countryside selling groceries and other items from a wagon. (Courtesy of Andrew Smith.)

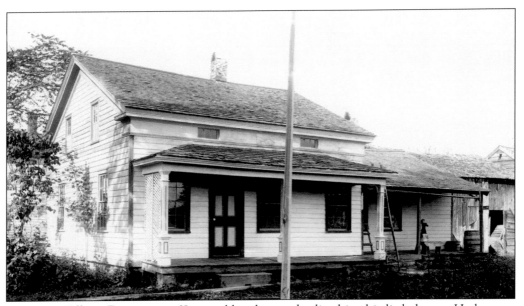

Capt. W. William Davis was a 69-year-old widower who lived in this little house. He became lonely, so in 1907, he started for Michigan in search of a new wife. He was given a name and address of a woman, but became suspicious of her reputation and observed her from a distance. His suspicions were correct. He then returned to his home at Delta. Originally from Rhode Island, he had come to the village seven years before and did odd jobs around the area. (Courtesy of Andrew Smith.)

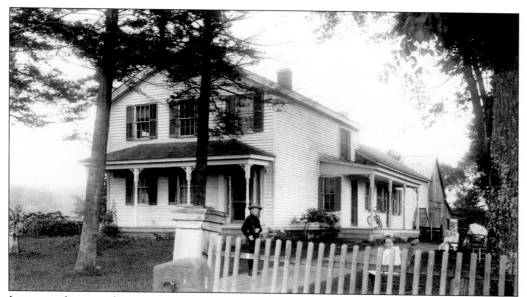

It is not clear on the maps exactly where the Lewis Evans home was located. Evans owned two parcels, a 5-acre parcel at the far end of Main Street and a 12-acre parcel located near Short Hill Road. He was the son of William Vincent and Mary Evans. Not much else is known about this family. (Courtesy of Andrew Smith.)

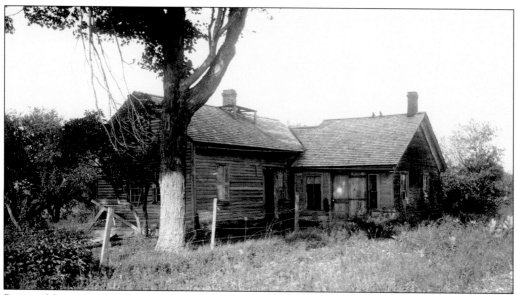

Pictured here is the home of Lewis M. Austin. The land was owned by Edward Hurlbut, and it is not clear where this property was located. Nothing is known about Austin. (Courtesy of Andrew Smith.)

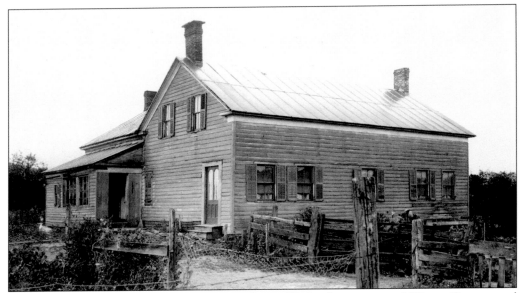

The Henry Jones farm was located on the road out of Delta that ran toward Wagers Corners and Westernville. At the location of this farm, the land rises to form a series of small hills. These hills today form the islands or high ground that rise when the lake becomes low. (Courtesy of Andrew Smith.)

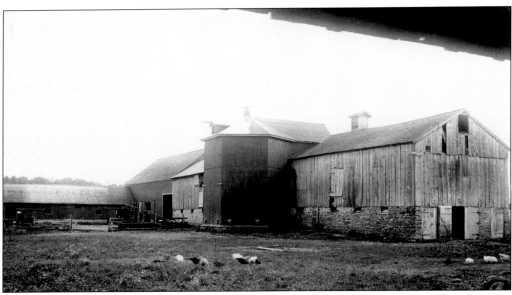

A magnificent barn and odd-shaped silo graced the 281-acre farm of Henry Jones. This farm was not far from the Wager estate, and this barn set on the river flats. The farm had a fine dairy herd and raised its own corn, grains, and hay. Since the soil near the river was very fertile, the farm had some record-breaking crops. (Courtesy of Andrew Smith.)

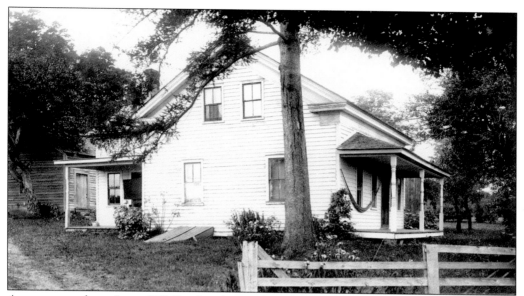

As one went down Long Hill Road and turned to the right away from the village, one came to another farm owned by David Anderegg. The road goes on to become a dead end in the meadows of the Bellinger farm. This home could have been a tenant house, and not much is know about the farm or who lived here. (Courtesy of Andrew Smith.)

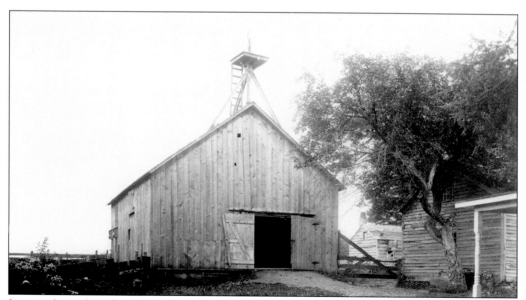

It is unclear what the strange contraption built on top of this barn was used for. It could have been a lookout tower to look for boats on the nearby Black River Canal. The barn sat on a rise of ground overlooking the road. Located on this farm were natural sulfur springs. (Courtesy of Andrew Smith.)

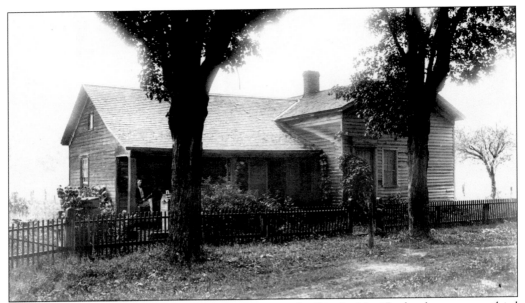

At the north end of Main Street, a short distance past the District No. 17 school, set on one-third acre of land, was the home of George and Jane Daniels. Farther down the road that went toward Stokes Corners were the farm buildings and sawmill that belonged to George. (Courtesy of Andrew Smith.)

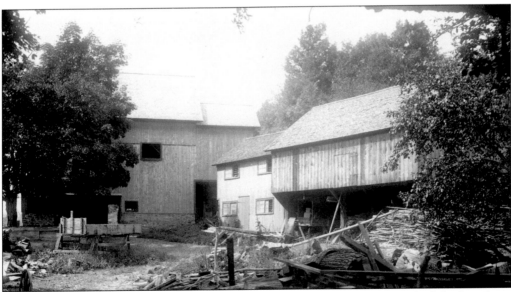

This is an unusual grouping of barns on the Daniels farm. In the lower level of the long barn appears to be a sawmill with stacks of wood outside. In the farmyard is a wagon being repaired, and on its side is painted the word *Delta*. On the hills above these barns, the state took a three-acre parcel to be used for a cemetery for the relocation of the older cemeteries in the area. (Courtesy of Andrew Smith.)

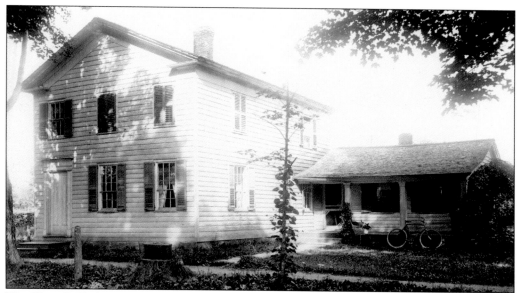

The Ebon F. Ely home was located in the north section of the village on the east side of Main Street. The home was pleasantly located on six acres of land with meadows that ran down to a cove on the Mohawk River. The cove was a favorite fishing and swimming spot for the locals. (Courtesy of Andrew Smith.)

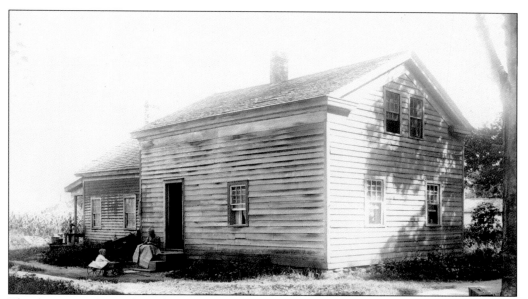

This home was located on the east side of Main Street close to the north end of the street. L. D. Adams was the local mechanic and craftsman who could turn his hand to any fine work. In 1895, he handcrafted a violin for Mary June Pillmore; it was a true work of art. Adams also worked at the Olney and Floyd canning factory for many years.

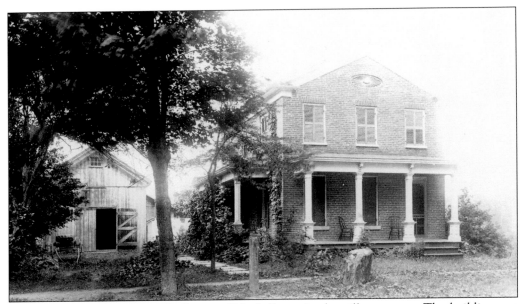

This lovely brick home was the home of Hugh Evans in the village proper. The building was built by the Byam brothers of the town of Lee from bricks burned in the courtyard. The home seems to be spacious. Hugh was the son of William Vincent and Mary Evans. (Courtesy of Andrew Smith.)

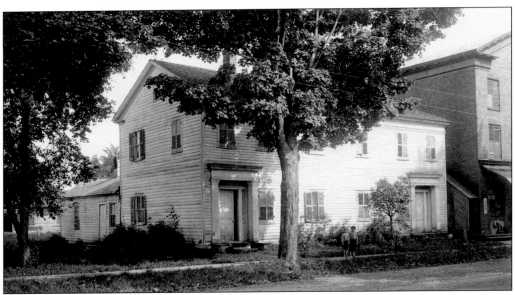

The long white apartments were located on Main Street next to the brick block. Charles Pillmore of Westernville owned the structure and rented the building to a Mr. Sweatman, who operated a harness shop in the south apartment and lived in the north apartment. (Courtesy of Andrew Smith.)

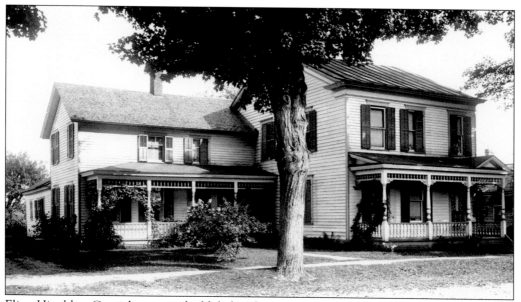

Eliza Hinckley Cornish, a grand old lady who was well liked for her sunny and cheerful disposition, lived in this classic home with its shutters and porches. Eliza was born in the town of Western and married Seth Cornish in 1856, and she lived in this home until the death of her husband in 1902. At that time, she moved to Lee Center to live with her daughter. (Courtesy of Andrew Smith.)

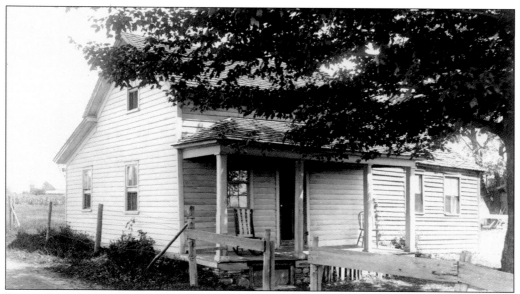

Joanna Murphy lived in this modest home between lock No. 9 and lock No. 10 of the Black River Canal. Behind the house can be seen the flatlands near the river and canal. Little is known about the Murphys or the farm. (Courtesy of Andrew Smith.)

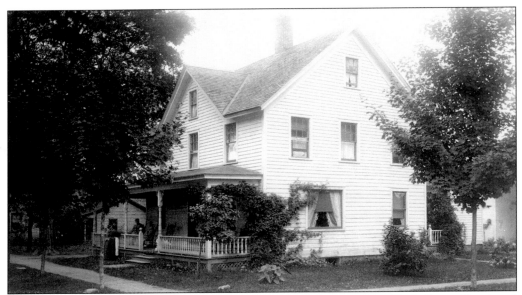

At a T on Main Street, the road goes over a steel bridge toward the Black River Canal and Westernville. Located on the corner was the home of Edward and Adelia Evans. Edward was born in Delta, the son of William Vincent and Mary Evans. He operated a farm at Wright Settlement before moving to Delta to run the sawmill.

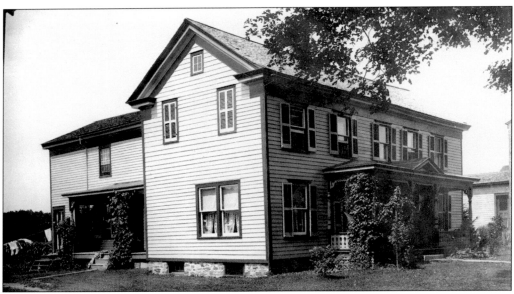

Frank and Lottie Harrington moved into this spacious home from their second-floor apartment over the brick block. The home was located on the west side of Main Street several doors up and across from the brick block. The building had been the former home of Roswell Raymond. (Courtesy of Andrew Smith.)

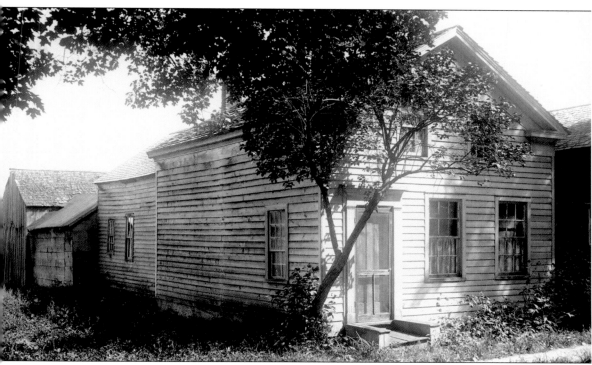

Across the street from the Methodist church parsonage on the east side of Main Street was the home of Charles Fuller and his wife. They were well along in their 80s enjoying the sunset of their lives when in 1908 they were forced to leave Delta. The state paid them $900 for their home, and the funds did not last long. After boarding with relatives, they ended up in the Oneida County home for the aged. Harry Harrington, who grew up in Delta and was a local attorney, was very fond of the couple. He made sure they had a room together at the county home, which was unusual for the time. Harrington provided the small comforts of life for the couple until their deaths. (Courtesy of Andrew Smith.)

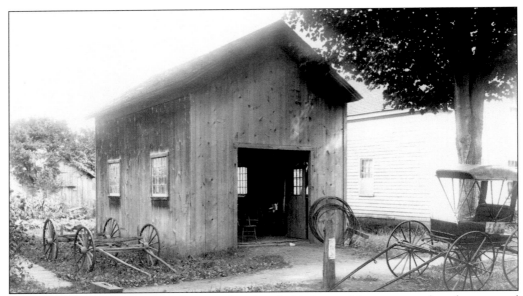

Charles Fuller ran a wagon and repair shop beside his home. He was a good craftsman, and many of the locals relied on him for wagon repairs. Behind the home was a fine garden, which he always planted June 1, when the soil was warm. (Courtesy of Andrew Smith.)

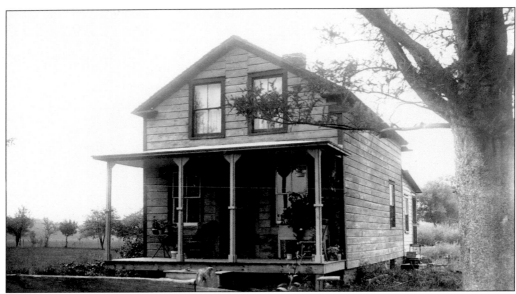

A small farmhouse was located on the 28-acre farm of Roscoe Keyes and was near the road that went to Westernville. Keyes only farmed here for a few years before moving to a farm at Stokes. Keyes was injured when he fell from an apple tree while picking apples and died several days later. (Courtesy of Andrew Smith.)

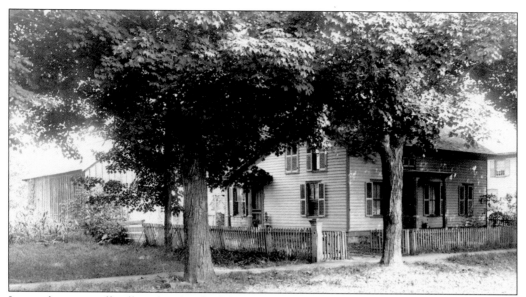

Located on a small village lot that had frontage of not more than 100 feet and went back to the bend of the river was Gertrude Jones's home, a nice house shaded by lovely maple trees. Not much is known about Jones except she was active in local church activities. (Courtesy of Andrew Smith.)

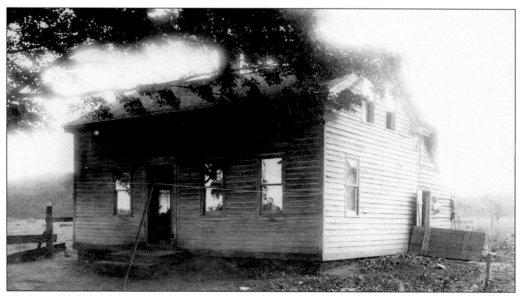

At the end of Short Street and across from the Oscar Smith brick house was the home of Levi O'Dell. O'Dell may have been a helper at the McIntosh blacksmith shop. When the O'Dells were forced to leave the village, they first moved to Rome and then on to Blossvale. (Courtesy of Andrew Smith.)

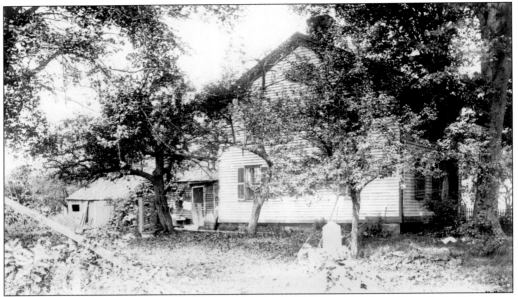

R. Bruce and Victoria Williams Nesbit purchased this home in 1883 from Eliza Peck. The home was originally built by Asa Hartshorn, who then sold it to his brother-in-law Richard Catlin. When the Nesbits were forced to leave the village, they moved to Elm Street in Rome. (Courtesy of Andrew Smith.)

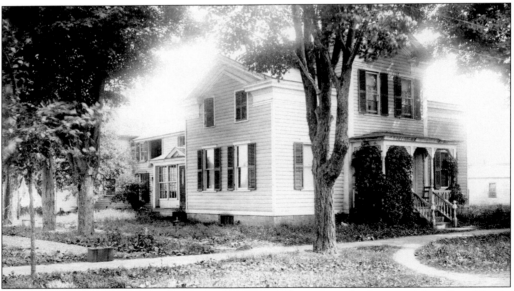

Next to the village green on the east side of Main Street was the home of Angeline Martin Hicks. Angeline and her husband, William, owned this lovely house in the village and a farm near the palisades. They had lived on the original Hicks homestead in the town of Western before moving to the village. This home was built in the 1840s by Eliakim Elmer to resemble the home of famous showman P. T. Barnum, a relative on his mother's side.

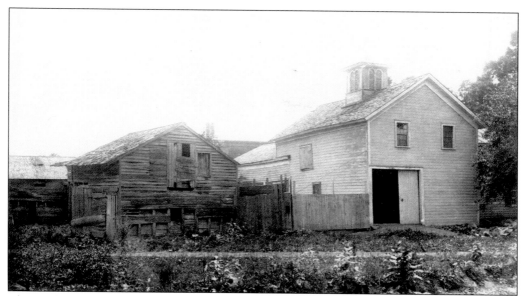

The Hicks farm was located close to the palisades and covered 82 acres of fertile farmland. The acreage was close to lock No. 12 of the Black River Canal and the road that went to Westernville. The farm had a fine dairy herd that was rated as one of best in the area. (Courtesy of Andrew Smith.)

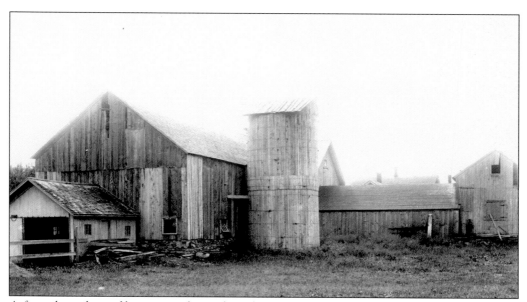

A fine silo and set of barns were located on the Hicks farm. Across the road from these barns, William Hicks owned another 11 acres of land where he grew the usual soil products. (Courtesy of Andrew Smith.)

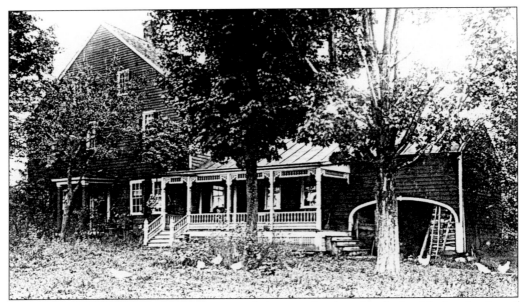

This photograph was among the collection of photographs that also dealt with the clearing of the site for the new reservoir. After many inquiries and research, no one seems to know where this mystery house was located. (Courtesy of the New York State Archives.)

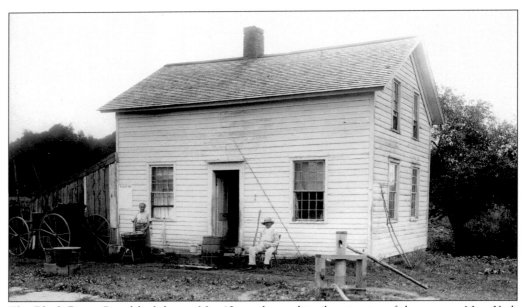

The Black River Canal lock house No. 13 was located in the vicinity of the current New York State park. When this photograph was taken, it must have been laundry day. Note the lady at the washtub using a washboard. This was a small modest home for the lock tender and his family. (Courtesy of Andrew Smith.)

Two

BUSINESS ENTERPRISES

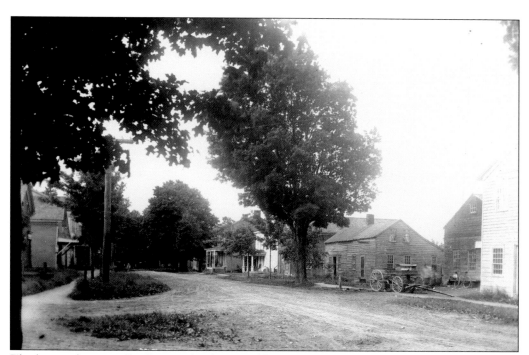

The heart of any small village is the shops and businesses that supply the needs of its residents. Villagers could shop at the brick store and pick up their mail, for the store also housed the post office. The village of Delta was also blessed with the Mohawk River and the nearby Black River Canal. It was a thriving area for business and the residents. Delta was an enterprising place, beneficial for all who lived there.

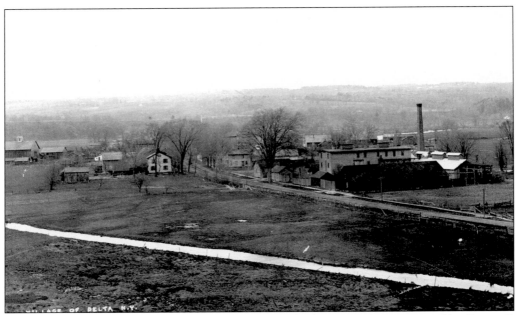

At the south end of Main Street was the Olney and Floyd canning factory, owned by George J. Olney Sr. and C. Frank Floyd. The canning factory was organized with many outbuildings designed for the smooth flow of raw product to cans. The cannery gave employment to many of the villagers and others in the area. (Courtesy of Tom Gates.)

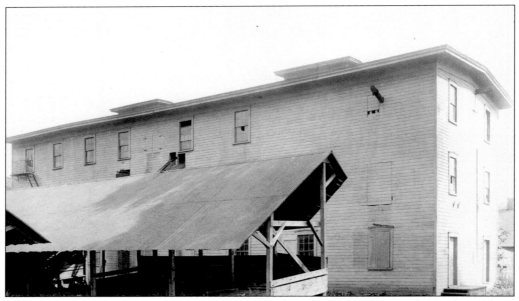

The task of canning corn, peas, green beans, succotash, and pumpkin was done here. The products were processed and packed by hand into cans that were made on-site. The cans were sealed, labeled, and put into wooden boxes ready for shipment. The finished product was transported by wagon or canal boats to many local and faraway markets. (Courtesy of Andrew Smith.)

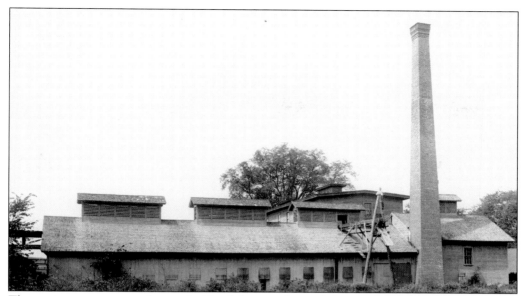

The engine room was on the north side of the complex and close to the back. The most notable feature of the engine room was its 95-foot brick chimney. The engine room supplied the steam needed to run the plant. This chimney was taken down with the help of a small amount of dynamite. The salvaged bricks were used at the new Lee Center canning factory. (Courtesy of Andrew Smith.)

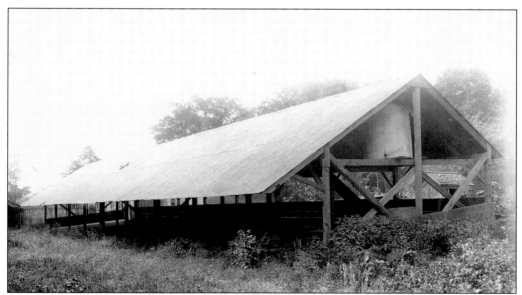

North of the engine room were the long sheds where the horse-drawn wagons piled high with produce waited to be unloaded. It was important that the produce be kept fresh and out of the direct sun. The farmers appreciated the fact that the horses could be kept out of the sun and be fed and watered. (Courtesy of Andrew Smith.)

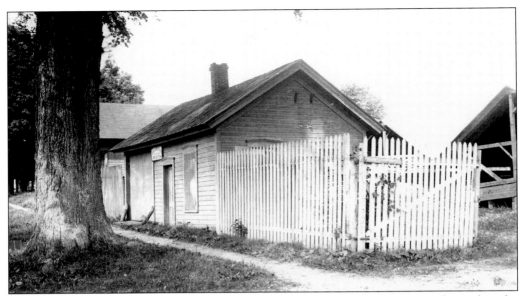

It was written by Mary June Pillmore that the office of the canning factory was located in the shade of an old ancient elm tree. It is small building for such a large and busy complex. The business did not have the office equipment of today, so it did not need much room. In later years, the business office was located in Westernville. (Courtesy of Andrew Smith.)

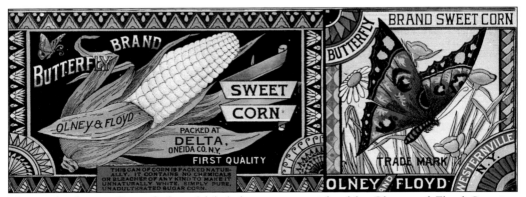

This is the famous Butterfly brand label that was copyrighted by Olney and Floyd Canning Company. This brand meant consistent, high-quality canned goods. The cannery did can under several different name brands. Now that the copyright on the Butterfly label has expired, one will find it used in many places. (Courtesy of Jack Olney.)

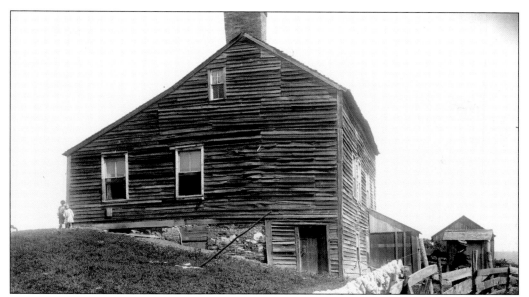

The old Native American trading post set on land settled by Gurdon Hurlbut in the early 1800s. It is not clear exactly who built this structure. Local folklore says that this building was close to 200 years old. The Native Americans from areas north would follow a footpath down to the Mohawk River at Delta and follow the river south. The Native Americans traded for the white settlers' goods, especially cooking pots and scissors. (Courtesy of Sylvia Kahler.)

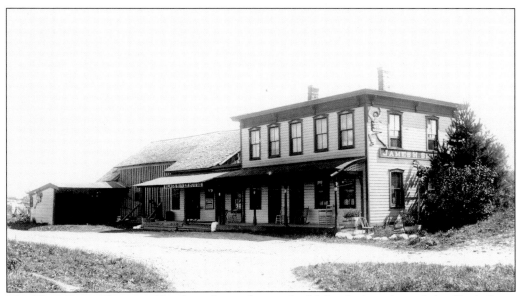

The Black River House or Hotel was located near the Mohawk Aqueduct of the Black River Canal and Mohawk River. The hotel was owned by William H. Smith, a veteran of the Civil War. Smith resided at the hotel, and after the land was taken, he moved to Westernville. The site was used for tax collection, political speeches, and temperance lectures. (Courtesy of Andrew Smith.)

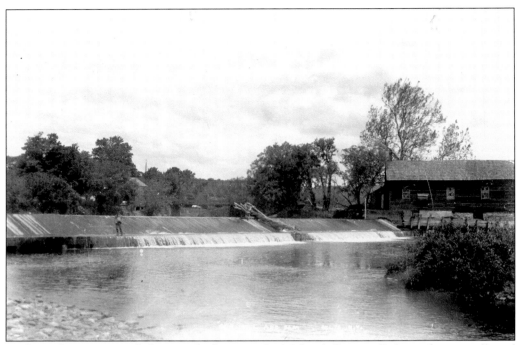

In the early 1800s, a mill dam was built across the Mohawk River at Delta to form a millpond to operate the nearby mills. Judge Prosper E. Rudd built the first gristmill at Delta. Anson Dart at one time owned the mill complex and improved the dam by laying limestone blocks seated with heated lead. The gristmill changed hands several times before it was purchased by the Walsworth family. (Courtesy of Tom Gates.)

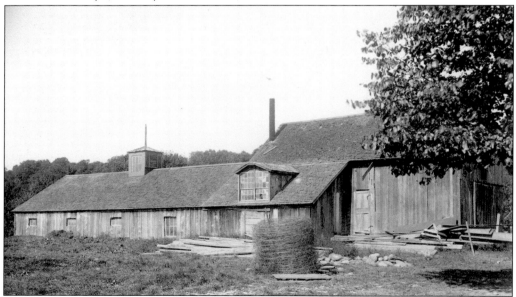

David Anderegg operated a successful sawmill on the banks of the Mohawk River on his farm near Westernville. The buildings are well kept and in good shape. Anderegg supplied the lumber needs of local farmers and builders. (Courtesy of Andrew Smith.)

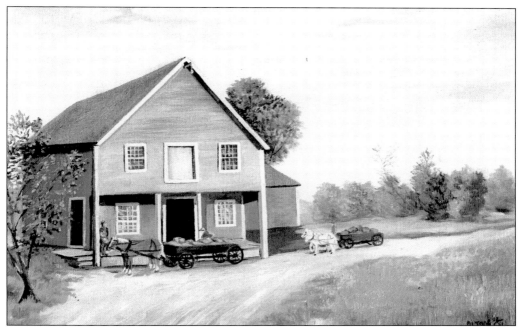

This is a nice view of M. B. Smith's cider mill as seen in this favorite Smith family painting. At one time, the mill was located on the east bank of the river but burned and Smith then built a new mill on the west side of the river. (Courtesy of Freida Royal Smith.)

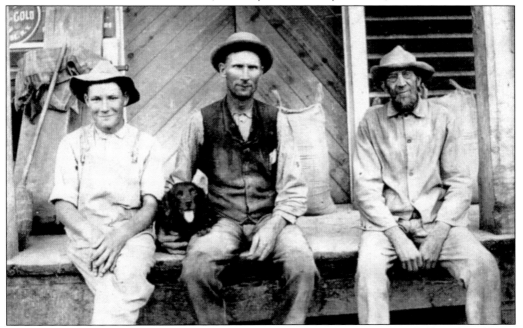

Seated in front of the cider mill are M. B. Smith (center) and his son Erwin (left) and a villager. Smith owned a 150-acre farm near Delta. The farm was the former home of Judge Ebenezer Robbins. Apple culture was the main feature of the farm. After leaving Delta, the Smiths moved to Westmoreland. (Courtesy of Freida Royal Smith.)

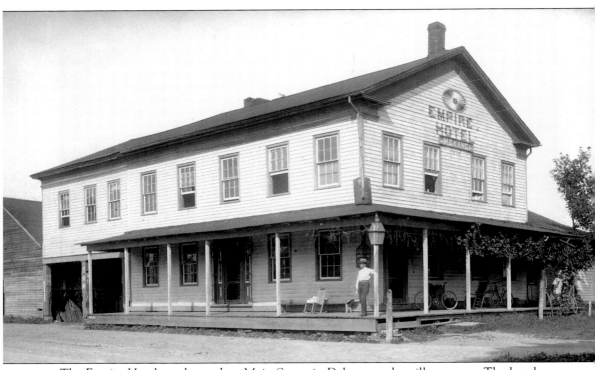

The Empire Hotel was located on Main Street in Delta near the village green. The hotel was a favorite spot in the village, being the stagecoach stop. The original building was built around 1852 by Eliakim Elmer, perhaps to coincide with the digging of the feeder for the Black River Canal. The "tavern stand" changed hands many times with Anna McCabe Kane being its last owner. She purchased the business in 1899. The building had a kitchen wing to the side and a wide porch that wrapped around from front to side. Inside there was a bar area, a dining room, a sitting room, and upstairs bedrooms. Local folklore says that upstairs there was a large ballroom and no bedrooms. In the 1899 deed when the property transferred to Anna McCabe Kane, along with the land, personal property was transferred, including the carpets and linoleum in the upstairs bedrooms. It is possible that the ballroom was located over the carriage barn, as was the style in hotels of that era. The ballroom was usually just a big open room and not an area with velvet curtains or crystal chandeliers. The ballroom was used for social, political, and academic gatherings.

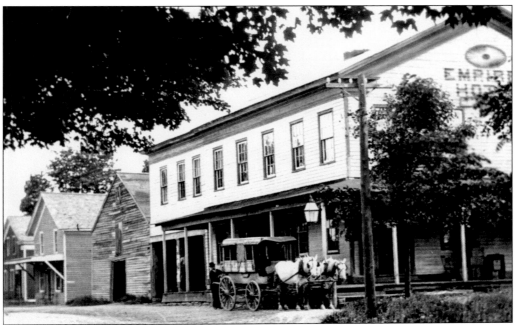

It was a sad day when the last stage arrived at the hotel. It was time to close the doors and throw away any keys, for they would not be needed anymore. The Kanes packed and moved to Floyd Avenue in Rome. Truly sad and busy days followed as the old building was dismantled and prepared to be moved.

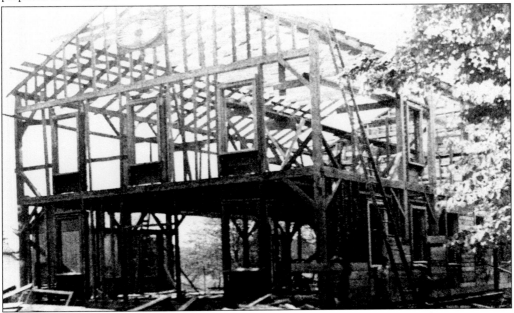

There was going to be a new life for the old hotel. A group of men formed a corporation and purchased the building for $2,500 and had it moved to Westernville. The building was dismantled, and the lumber, windows, doors, and moldings were marked for reassembly. The pieces were then moved by horse and wagon over the old River Road to its present location.

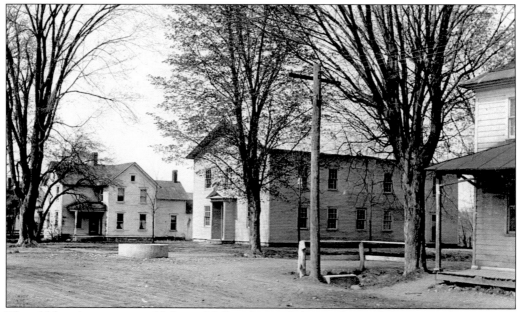

The old hotel was renamed Liberty Hall and served the residents of the town of Western as a meeting place. Downstairs the building was redesigned with two large rooms, a kitchen, bathrooms, two small offices, and a storage area. Upstairs is a large auditorium with a stage. At various times, the post office and library were located within its walls.

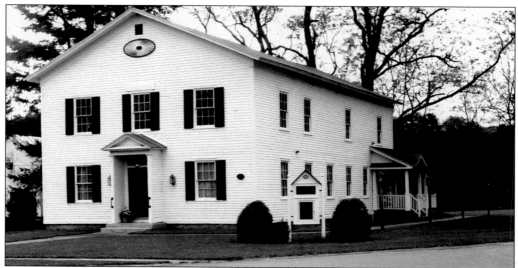

In 1961, the old Liberty Hall was purchased from the corporation by the Town of Western to be used as a town hall. The town board, town justice, planning board, and zoning board of appeals use this building on a regular basis. In 1995, the building was placed on the National Register of Historic Places, thus recognizing its historical significance in the former village of Delta and now its importance to the town of Western.